*M*o ION

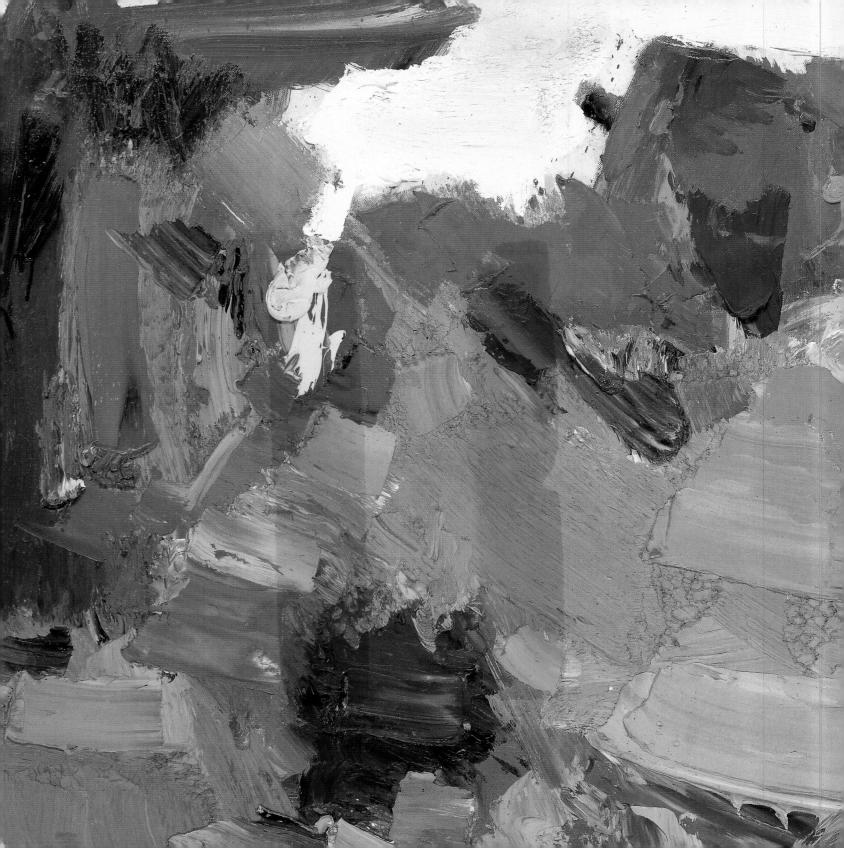

MODERNISM & ABSTRACTION

Treasures from the
Smithsonian American Art Museum

Miranda McClintic

Watson-Guptill Publications/New York

Smithsonian American Art Museum

Modernism & Abstraction: Treasures from the Smithsonian American Art Museum

By Miranda McClintic

Chief, Publications: Theresa Slowik
Designers: Steve Bell, Robert Killian
Editor: Mary J. Cleary
Editorial Assistant: Sara Mauger

Library of Congress Cataloging-in-Publication Data

McClintic, Miranda
 Modernism & abstraction : treasures from the Smithsonian American Art Museum / Miranda McClintic.
 p. cm.
Includes index.
 ISBN 0-8230-3123-3
 1. Modernism (Art)—United States—Exhibitions.
2. Art, Abstract—United States—Exhibitions.
3. Art, American—Exhibitions. 4. Art, Modern—20th century—United States—Exhibitions.
5. Art—Washington (D.C.)—Exhibitions.
6. Smithsonian American Art Museum—Exhibitions.
I. Title: Modernism and abstraction. II. Smithsonian American Art Museum. III. Title.
 N6512.5.M63 M39 2001
 709'.73'074753—dc21
 00-013058

Printed and bound in Italy

First printing, 2001
1 2 3 4 5 6 7 8 9 / 08 07 06 05 04 03 02 01

Cover: Willem de Kooning, *The Wave,* about 1942–44,
oil. Smithsonian American Art Museum, Gift from
the Vincent Melzac Collection (see page 22).

Frontispiece: Hans Hofmann, *Fermented Soil* (detail),
1965, oil. Smithsonian American Art Museum, Gift
of S. C. Johnson & Son, Inc. (see page 38).

Modernism & Abstraction is one of eight exhibitions in *Treasures to Go,* from the Smithsonian American Art Museum, touring the nation through 2002. The Principal Financial Group® is a proud partner in presenting these treasures to the American people.

Foreword

Museums satisfy a yearning felt by many people to enjoy the pleasure provided by great art. For Americans, the paintings and sculptures of our nation's own artists hold additional appeal, for they tell us about our country and ourselves. Art can be a window to nature, history, philosophy, and imagination.

The collections of the Smithsonian American Art Museum, more than one hundred seventy years in the making, grew along with the nation itself. The story of our country is encoded in the marvelous paintings, sculptures, and other artworks we hold in trust for the American people.

Each year more than half a million people come to our home in the historic Old Patent Office Building in Washington, D.C., to see great masterpieces. I learned with mixed feelings that this neoclassical landmark was slated for renovations. Cheered at the thought of restoring our magnificent showcase, I felt quite a different emotion on realizing that this would require the museum to close for three years.

Our talented curators quickly saw a silver lining in the chance to share our greatest, rarely loaned treasures with museums nationwide. I wish to thank our dedicated staff who have worked so hard to make this dream possible. It is no small feat to schedule eight simultaneous exhibitions and manage safe travel for more than five hundred precious artworks for more than three years, as in this *Treasures to Go* tour. We are indebted to the dozens of museums around the nation, too many to name in this space, that are hosting the traveling exhibitions.

The Principal Financial Group® is immeasurably enhancing our endeavor through its support of a host of initiatives to increase national awareness of the *Treasures to Go* tour so more Americans than ever can enjoy their heritage.

Modernism & Abstraction follows two threads that are interwoven through twentieth-century art. One explores primal desires and inner spirit as a source of inspiration; the other responds to the increasing importance of technology and the quicker pace of its cycles. In modernist works of the twentieth century, the technological and the spiritual meet in works that are intense and symbolic.

Early in the century, American artists eagerly adopted ideas and techniques from Europe. Many continued to study abroad, and mid-century, waves of immigrant artists brought new ideas to the United States. As Americans came and went across the Atlantic, they absorbed the lessons of fauvism, cubism, and other revolutionary movements, translating them into a native idiom. The contact of cultures produced a heady broth of new ideas that nourished a strong community of artists in New York. Soon it was ready to take its place as an international capital of ideas.

American artists were quick to experiment with pure abstraction. Others, such as Stuart Davis, adopted the new language of popular culture, referencing film, jazz, and all the joyous cacophony of urban life. For still others, nature has been the surest inspiration during turbulent times, as they use organic forms to express intense personal experiences.

The Smithsonian American Art Museum is planning for a brilliant future in the new century. Our galleries will be expanded so that more art than ever will be on view, and we are planning new exhibitions, sponsoring research, and creating educational activities to celebrate American art and understand our country's story better.

Elizabeth Broun
Margaret and Terry Stent Director
Smithsonian American Art Museum

JOSEF ALBERS

1888–1976

Homage to the Square — Insert

1959, acrylic
121.9 x 121.9 cm
Smithsonian
American Art
Museum, Gift of
S. C. Johnson
& Son, Inc.

Homage to the Square—Insert, which exists at the minimal extremes of abstract art, belongs to a twenty-seven-year-long series of paintings and prints. The title testifies to Josef Albers's belief in the rich artistic possibilities of this fundamental geometric form, variously defined by the interactions and illusions of several colors.

Homage to the Square—Insert exemplifies Albers's lifelong exploration of the retinal, psychological, and spiritual qualities of color. Here, a dense yellow center appears, alternatively, to be set on a bright white square within square frames of light gray and tan, and to be optically pulsing out from within its boundaries.

Albers based his theories and work on direct experience of the distinct properties of the materials, forms, and colors that he used. As a utopian, he believed that "Art is spirit and only the quality of spirit gives the arts an important place in . . . life."

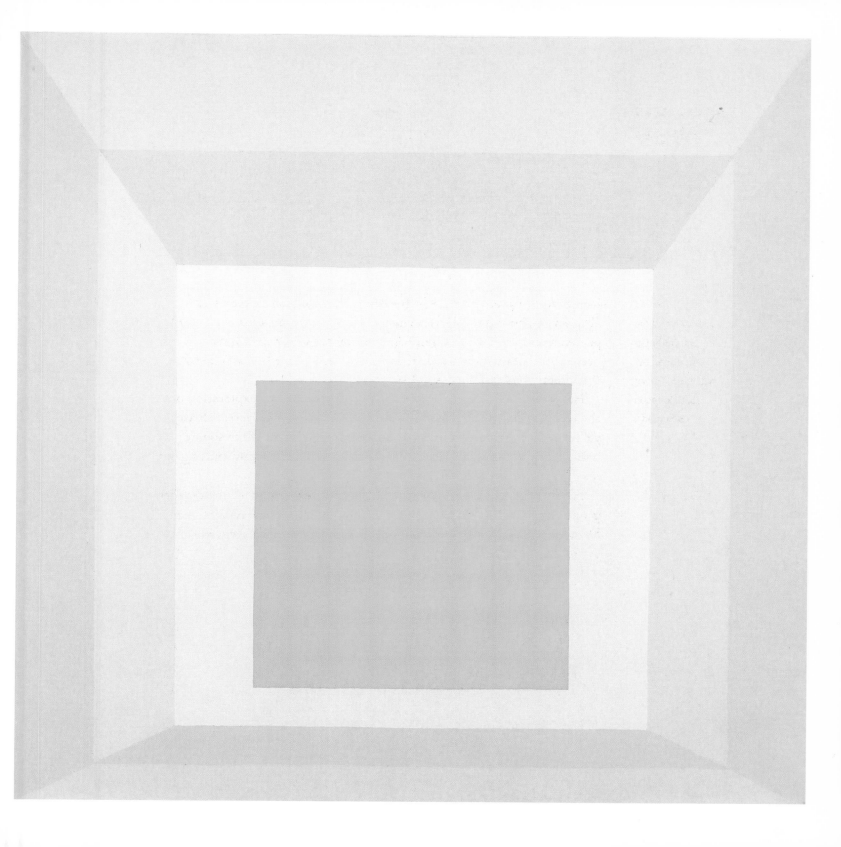

MILTON AVERY

1885–1965

Spring Orchard

1959, oil
127 x 168.3 cm
Smithsonian
American Art
Museum, Gift of
S. C. Johnson
& Son, Inc.

A fluffy mass of plum-colored trees curves in a welcoming embrace and dissolves into a path. The green hillside flows across the surface, defining the horizon. The awkward angles of spindly tree trunks enliven this pastoral image, abstracted and distilled from the memory of a spring orchard in bloom.

Avery simplified forms and used color to capture the essence of nature. He learned from Matisse and taught Mark Rothko to use color to create mood. Here, the pale green hillside, vigorous brushwork in the trees, and opaque pink ground combine into peaceful grandeur.

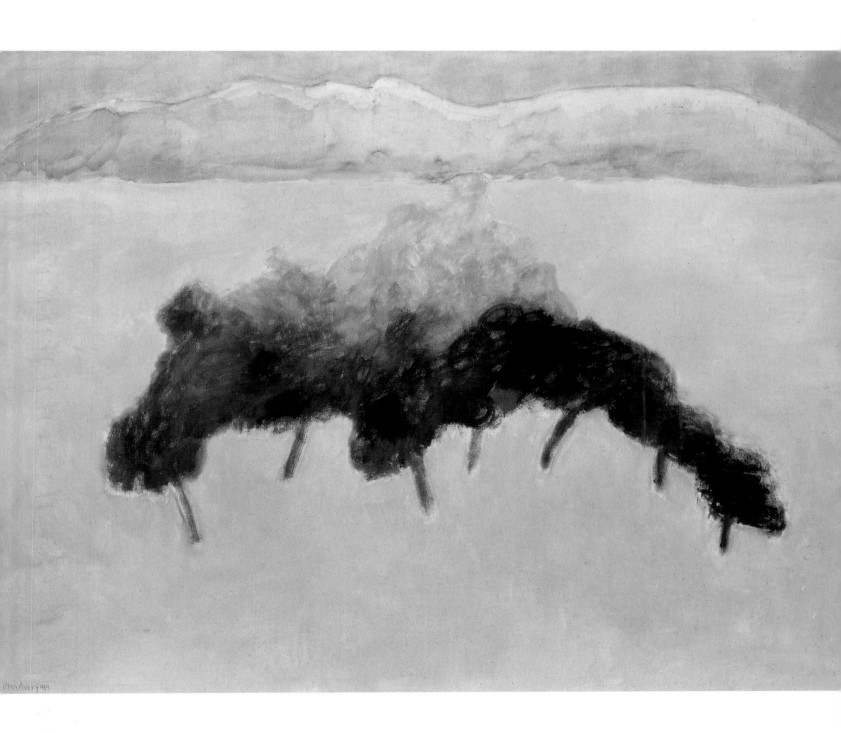

WILLIAM BAZIOTES

1912–1963

Scepter

1960–61, oil
167.7 x 198.4 cm
Smithsonian
American Art
Museum, Gift of
S. C. Johnson
& Son, Inc

William Baziotes painted primeval dreamworlds. Here, two presences seem to confront each other in a mythic encounter. Their buoyancy and the dappled background evoke a primordial sea, but this ancient broth already contains in the sceptered form the germ of pride and complexity that evolved in later, human life.

This netherworld brims with both stillness and drama. Baziotes has created an alternative reality for himself and his audience, and provided us with a key. His titles, he said, give "the feeling of the meaning of the picture."

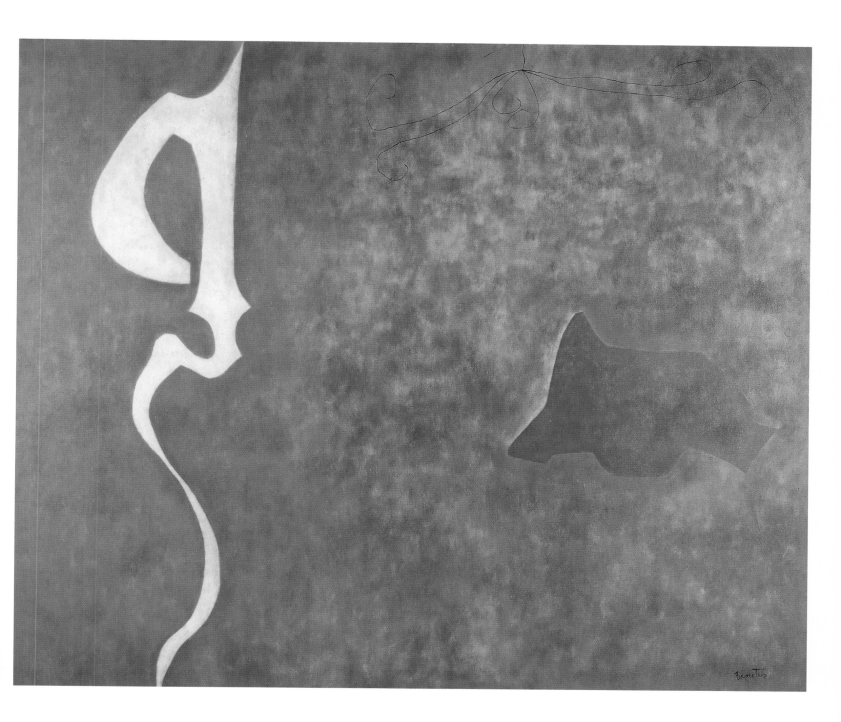

FREDERICK BROWN

born 1945

Stagger Lee

1984, oil
228.6 x 355.6 cm
Smithsonian
American Art
Museum

Stagger Lee is a mythic character, a black antihero who shot another man dead in an argument over a hat. Brown knew the legend well from the many versions of the myth in jazz and blues songs. He positioned Stagger Lee in solidarity with other outsiders: a pilgrim, an Indian, a labor leader, and Christ on the cross all find a place here. With intersecting arms and staring eyes, they stand together in compact overlapping interrelation. Rugged brushwork, strident coloring, anatomical distortions, and inversions of scale give *Stagger Lee* its expressive intensity. Frederick Brown sees himself as an artist/shaman who paints the complexity of human life and American society, and brings enlightenment.

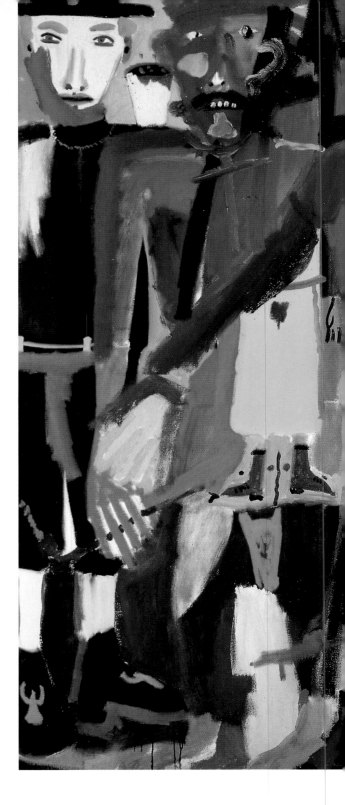

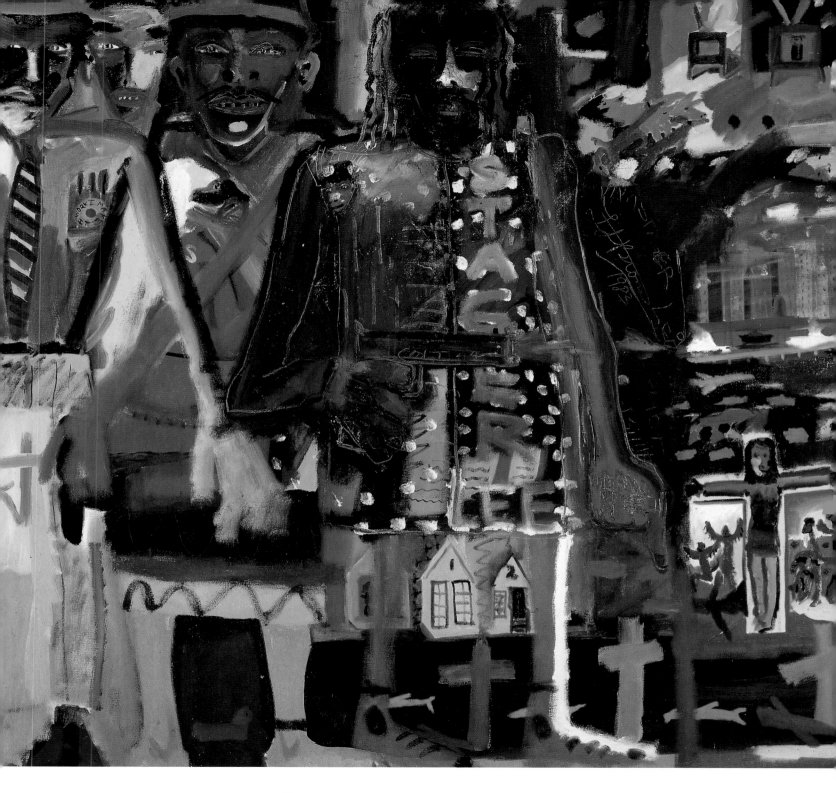

WILLIAM CHRISTENBERRY

born 1936

Alabama Wall I

1985, metal
and tempera
115.3 x 128.3 cm
Smithsonian
American Art
Museum

Metal signs, old license plates, and corrugated tin siding project a familiar aura that makes these castoffs both evocative and communicative. For Christenberry, the license plates specifically evoke the summer drive to his Alabama birthplace, even as they celebrate the year of his birth with the number "36."

Alabama Wall I strongly speaks of the rural South, especially his homeland, Hale County, Alabama. Its picturesque country shacks, churches, and weathered barns have inspired Christenberry's assemblages, sculpture, photography, and painting during the course of several decades. Though he left Alabama decades ago to make his home in Washington, D.C., Christenberry creates work that remembers the South from the position of an insider—with both loving sentiment and an incisive eye for its complexities.

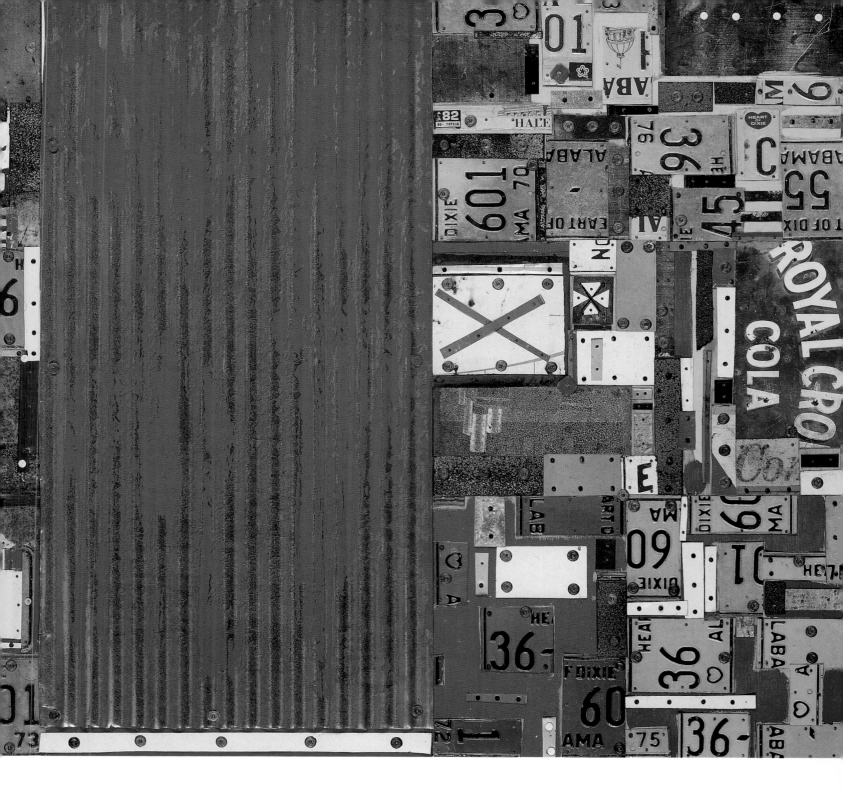

GENE DAVIS

1920–1985

Black Grey Beat

1964, acrylic
230.5 x 475 cm
Smithsonian
American Art
Museum, Gift from
the Vincent Melzac
Collection

Ten striking colors establish a lively syncopated rhythm across the canvas. These equal-width stripes are not only on the canvas, but identical with it. There is no figure/ground relationship and no perspective.

Gene Davis said that for him the stripe was a subject like a nude, landscape, or still life. Although these stripes appear carefully orchestrated, they are colored, proportioned, and arranged intuitively. Davis recommended that people enter the painting by following a single color in and out across its surface. A dedicated music-lover, he created a distinctive movement of color in each of his paintings, drawings, and prints.

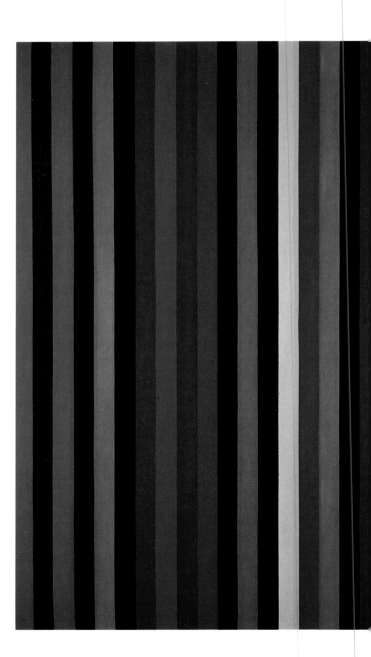

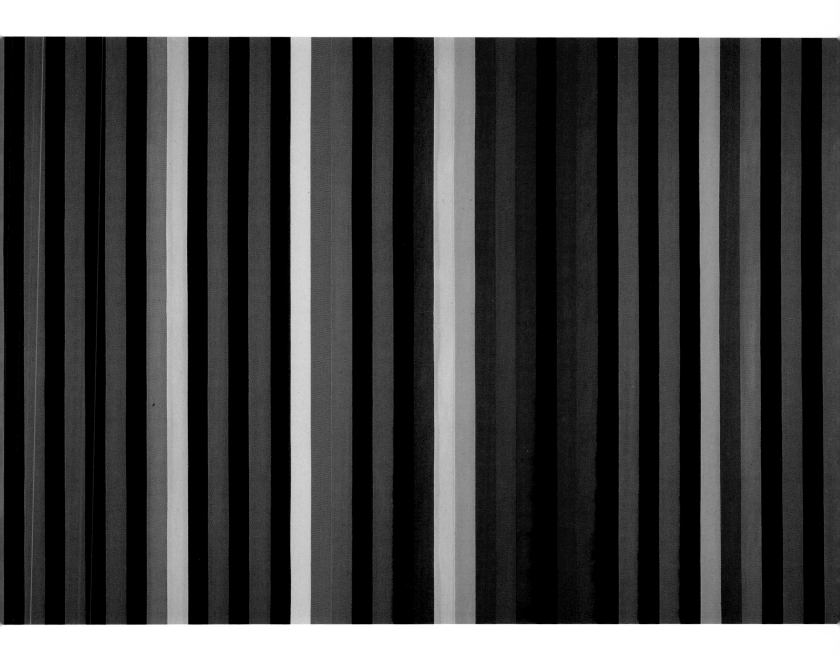

STUART DAVIS

1894–1964

Int'l Surface No. 1

1960, oil
145.2 x 114.6 cm
Smithsonian
American Art
Museum, Gift of
S. C. Johnson
& Son, Inc.

Int'l Surface No. 1 is full of movement, rhythm, repetition, and strong color, probably reflecting the jazz Stuart Davis listened to while working. One of seven artists invited by *Fortune* magazine in 1956 to create modern still lifes from things purchased at a supermarket, Davis borrowed the clarity of form and bold coloring of the packaging that inspired it. He simplified and enlarged the flat, hard-edged planes he adopted from cubism, updating his style for the era of pop art.

Davis disassociated the packaging from the products and separated labels from their wrapping, capturing the fragmented and disjunctive liveliness of modern America at mid-century. He made twenty-nine studies in which he simplified and stylized images and words into pictographs. Over time, he executed several paintings and a number of drawings on this same subject.

WILLEM DE KOONING

1904–1997

The Wave

about 1942–44, oil
121.9 x 121.9 cm
Smithsonian
American Art
Museum, Gift from
the Vincent Melzac
Collection

Willem de Kooning's *The Wave* has the mythic moodiness of American painting during and immediately after World War II, when it was influenced by contemporary world affairs and surrealism. The title suggests a gesture of a hand, or a seascape, but we see neither. Instead there is a brooding shape whose Madonna-like posture hints at the many women who soon would crowd into de Kooning's paintings, to become a dominant subject of his art.

Thinly painted colors are defined and animated by precise drawing that separates figure from ground. The expressive freedom of this drawing is held in check by a primal glowing orb hovering over the green field, creating a mysteriously generative scene. From early works through his last paintings in 1997, de Kooning's organic abstraction came from his direct experience of nature, in both landscape and the female body. *The Wave* is a rare painting that combines abstract representations of both.

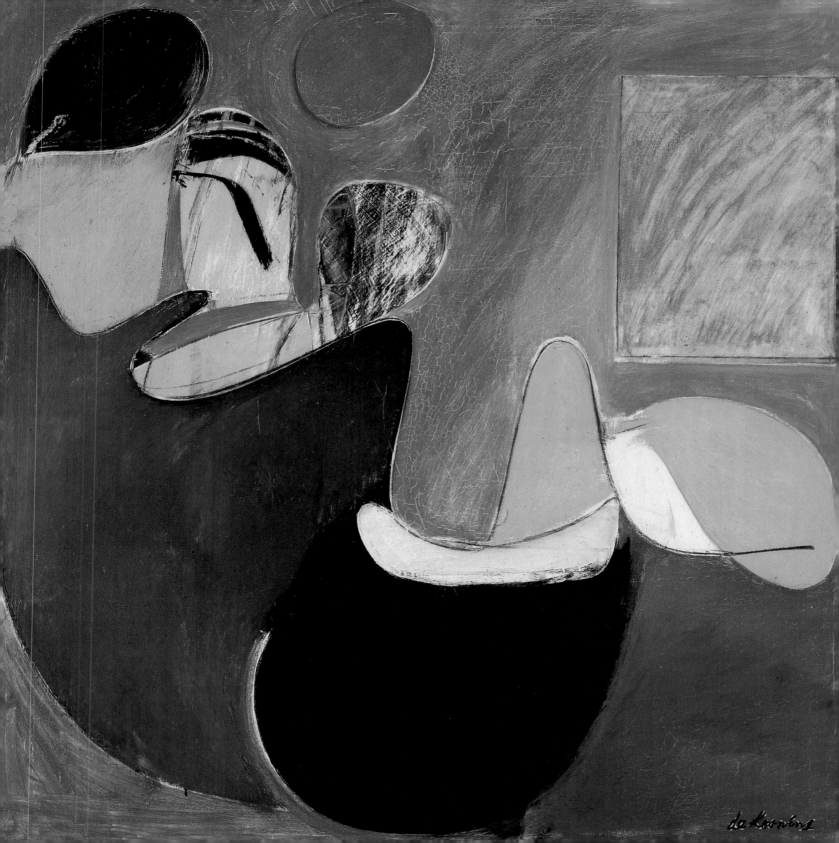

ARTHUR DOVE

1880–1946

Sun

1943, wax
sheet: 7.6 x 10.2 cm
Smithsonian
American Art
Museum, Bequest of
Suzanne M. Smith

Arthur Dove's animistic approach to nature is seen in the strong attraction between the radiating sun and its reflection on the ground. We feel the waves of solar energy and the gravitational pull of the curving earth. This intensity is reinforced by the compressed space, thickly impastoed surface, and echoing silhouettes. *Sun* shows us landscape condensed to its essentials, using primal shapes and three colors (pure, and intermixed two at a time, in varying proportions).

Symbolic in their subjects and colors, Dove's works established new correspondences between images, lines, hues, and sounds that were derived from the surrounding world, then simplified and magnified to depict a universe of his own imagining.

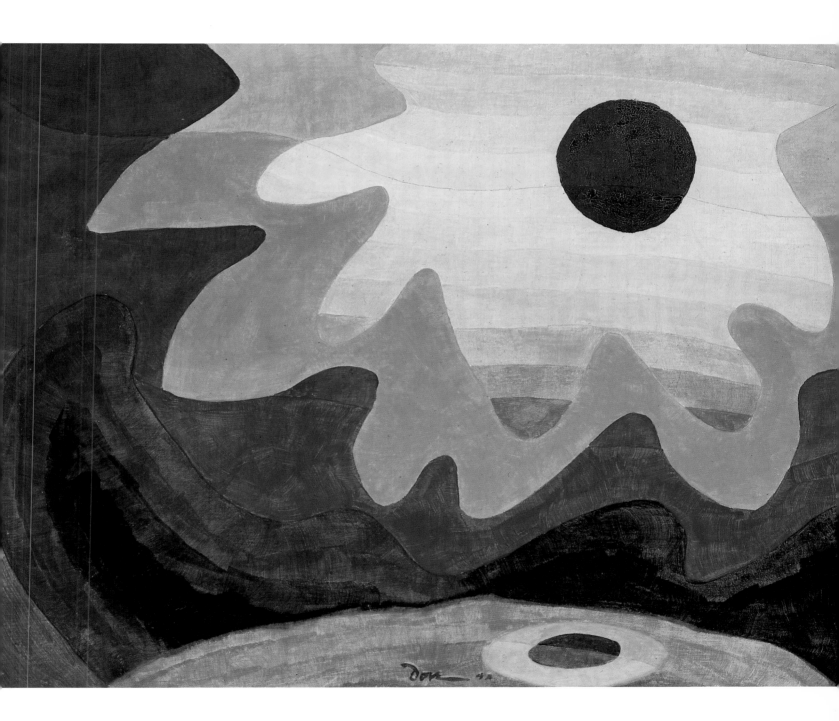

SAM FRANCIS

1923–1994

Blue Balls

1960, oil
229.6 x 199.8 cm
Smithsonian
American Art
Museum, Gift of
S. C. Johnson
& Son, Inc.

With its empty center, *Blue Balls* expands from the pictorial field into the world beyond the canvas. The implied forces of disbursal and containment act out a struggle that feels profoundly human. Sprays and veils of paint activate an energy flow among the nine buoyant amoebic blobs floating along the picture's edge. The dialogue between blue and white, as well as the measured relationship between the forms and the intervals that separate them, activates the void, transforming it into space.

Sam Francis created engaging visual experiences that are abstract analogues of life's conditions. He used blue exclusively from 1960 to 1962 because of the color's associations with the universe, transcendence, infinity, and darkness that allow it to speak to the unconscious. *Blue Balls*'s intensity may be due to the fact that its biomorphic globules, reminiscent of blood cells under a microscope and the shape of a kidney, appeared in Francis's paintings several months before the artist was diagnosed with tuberculosis of the kidney. He later realized, "I was flying off in all directions at the time and the *Blue Balls* series was a way to contain myself."

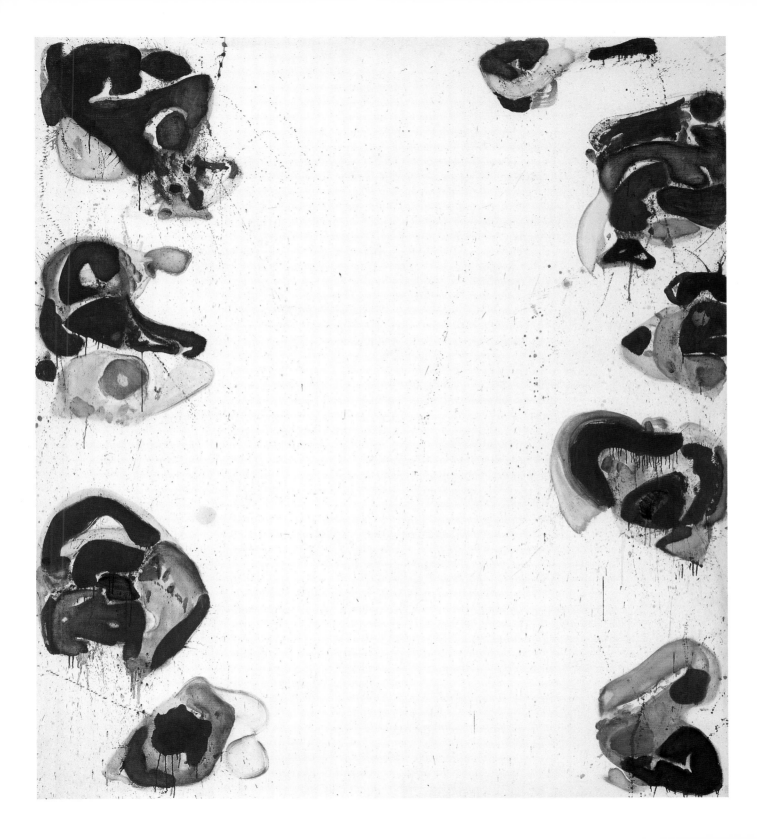

HELEN FRANKENTHALER

born 1928

Small's Paradise

1964, acrylic
254 x 237.7 cm
Smithsonian
American Art
Museum, Gift of
George L. Erion

Small's Paradise is named after both a fashionable Harlem nightclub and the central image of paradise in a Persian manuscript illumination. Helen Frankenthaler evokes a floating fantasy of color, light, and air. There are a series of enclosures, but the interactions of the different colored areas are the real subjects of this painting.

There is no trace of the artist's hand. Starting with the pink/red center, making up the image as she works, Frankenthaler created shape with color rather than with line, pouring acrylic paint onto unstretched canvas on the floor. The colored forms are flat in the surface of the canvas, while suggesting illusionistic atmosphere in depth with subtle shifts in tonal intensity and by the retinal properties of pink, green, and blue. *Small's Paradise* affirms the pleasure inherent in the sensuous beauty of painting.

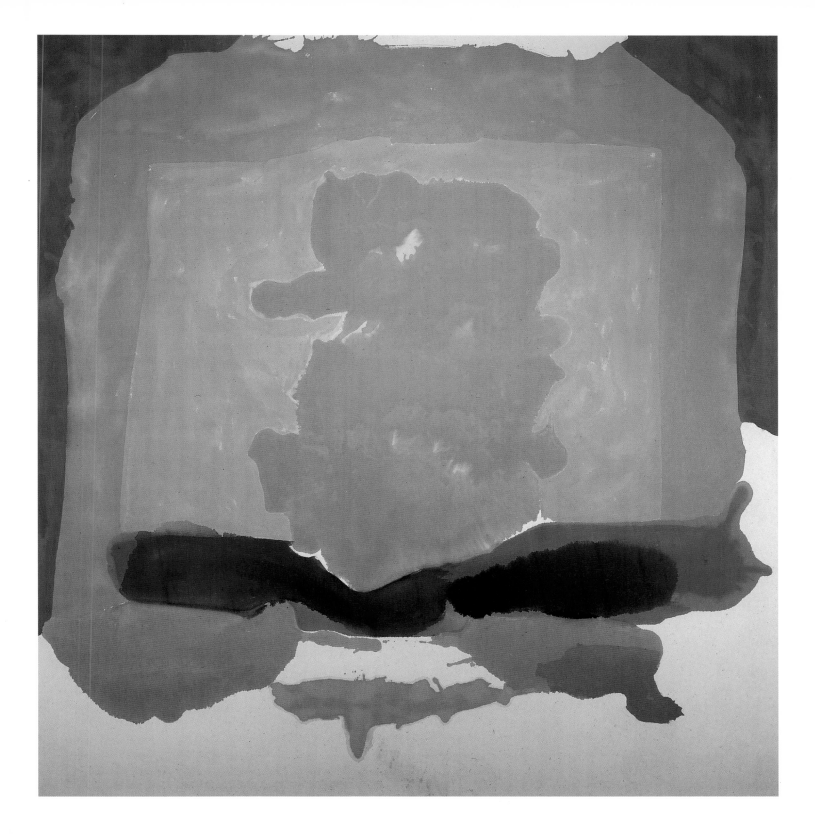

SUZY FRELINGHUYSEN

1911–1988

Composition—Toreador Drinking

1944, oil
129.9 x 89.3 cm
Smithsonian
American Art
Museum,
Museum purchase
through the
Luisita L. and
Franz H. Denghausen
Endowment

Suzy Frelinghuysen brought humor and elegance to synthetic cubism. In *Composition—Toreador Drinking,* a slender character sits up straight, with glass and carafe nearby, locked within a checkerboard construction that simplifies figure and setting to the same formal common denominator. The unusual combination of yellow and blue-gray is both pleasing and tart. Sensuous contours endow the figure with vitality, and different textures appeal to our sense of touch. Balanced and orderly, the composition is still engagingly complex. Frelinghuysen worked intuitively, using shadows and formal pairings with wit that softens the painting's late cubist rigidity.

A founding member of the American Abstract Artists and a collector who helped introduce avant-garde European art to the United States, Frelinghuysen was also a professional opera singer. Her life exemplified a modern ideal—the crossbreeding of art and design, internationalism, style, and dedication to self-realization through art.

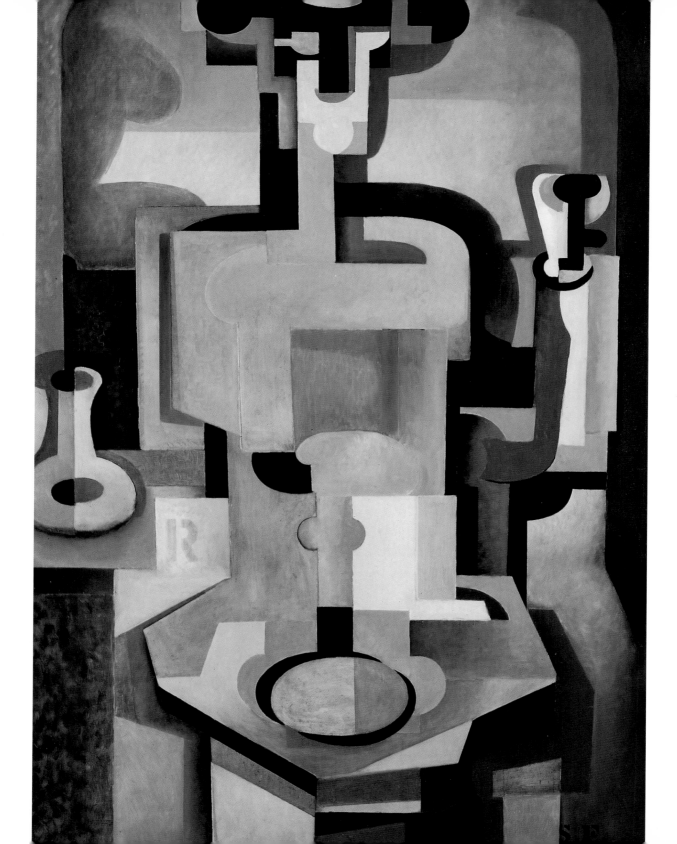

PHILIP GUSTON

1913–1980

Transition

1975, oil
167.6 x 204.5 cm
Smithsonian
American Art
Museum, Bequest of
Musa Guston

The pain in this painting is conveyed by the pile of abandoned, perhaps bloodstained shoes, and by the depiction of the artist's hand holding a canvas's back so that the stretcher resembles a guillotine supporting five amputated fingers. Painted while Philip Guston was not well, *Transition* contains thoughts of death. The artist is obscured behind the edges of two canvases; a miniature door awaits, and a clock marks his time. The shoes evoke the horrors of the Holocaust.

But Guston's work is also about metamorphosis. The title *Transition* encompasses a wide range of relationships, and suggests we are looking at a symbolic representation of a life's journey, starring the modern artist, an alter ego for Guston himself. The work is highly personal, and yet is expressive in ways that are generally comprehensible. Captivated by the mystery of ordinary objects, Guston transformed them with his feelings and ideas. He painted in order to give concrete reality to his thoughts.

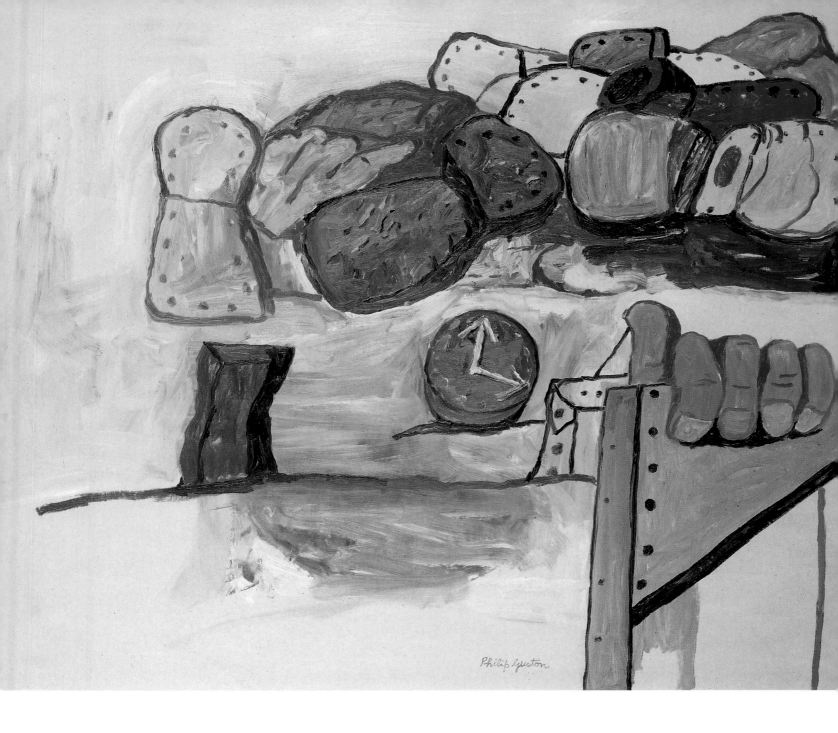

Philip Guston

MARSDEN HARTLEY

1877–1943

Yliaster (Paracelsus)

1932, oil
64.1 x 72.4 cm
Smithsonian
American Art
Museum,
Museum purchase
made possible by the
Smithsonian
Institution Collections
Acquisition Program
and by George
Frederick Watts and
Mrs. James Lowndes

This painting fuses Mayan, Aztec, and Catholic imagery, commemorating the moment of creation, when a stream of fire links the sun and the volcano. The title and subject refer to the writings of the sixteenth-century Swiss physician and alchemist, Paracelsus. With vivid colors, harsh dry geometry, and forceful brushwork, Hartley created an icon of power (the phallic shaft of light/tower), sustenance (the pool of water with upward cascading water that parallels the light shaft in shape), and energy (the sun disk).

Throughout his life, Hartley studied German Romantic philosophy, transcendentalism, theosophy, mysticism, Eastern religions and the occult, forging his own belief systems from their combined wisdoms. These exotic interests focused his painting toward representations of the spiritual energy of nature, which was the subject of much of his work.

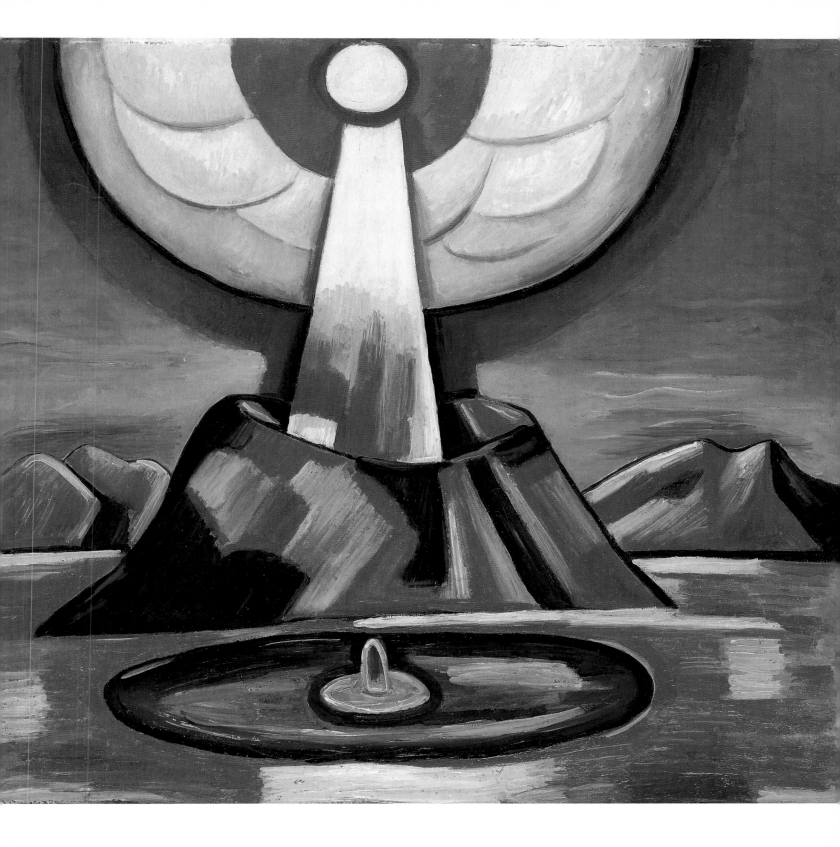

DAVID HOCKNEY

born 1937

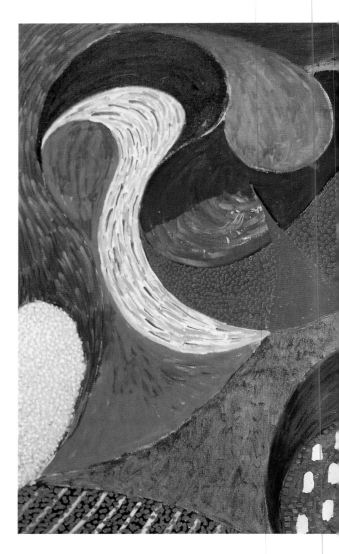

Double Entrance

1993–95, oil
182.9 x 426.7 cm
Smithsonian
American Art
Museum,
Museum purchase
through the Luisita L.
and Franz H.
Denghausen
Endowment

Inspired by drives on the winding roads near Los Angeles, *Double Entrance* provides two means of visual access into the picture, which you enter as if turning into a driveway. The pleasures of double entrances—alternative possibilities— are expressed through color and space in this acrobatic arabesque. Hockney energizes us with his futurist crescents, virtuoso paint handling (flat, dappled, softly bushed, striped, and spotted), and high-key, assertive coloring.

The curvilinear action is enhanced by the way Hockney plays the two sides of the composition against each other. He establishes distinctly different interweaving directional patterns on the right and left sides of the canvas, each moving at its own rhythmic pace. Hockney controls the way the eye moves around the painting, and the speed, but gives the viewer plenty of opportunities for leaping from one pathway to another.

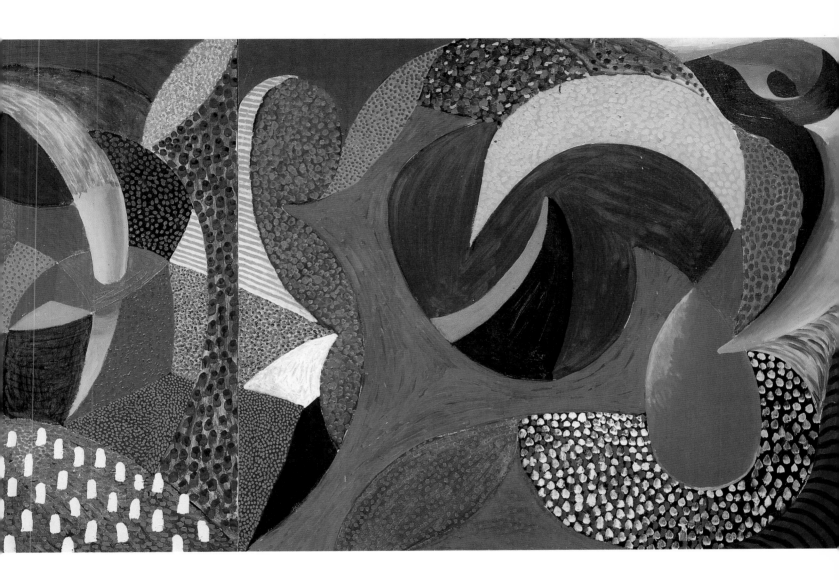

HANS HOFMANN

1880–1966

Fermented Soil

1965, oil
121.8 x 152.4 cm
Smithsonian
American Art
Museum, Gift of
S. C. Johnson
& Son, Inc.

The title *Fermented Soil* accurately describes this muddy mess, which becomes more beautiful the longer you look at it. This mixing of expressive color, thick creamy impasto, contrasting hues, and optical dynamics combines and transforms different ingredients in a process similar to fermentation. Hofmann presents the fecundity of paint as analogous to the fecundity of the earth, from which the colors are made.

Hans Hofmann, like Josef Albers, was one of the great teachers of abstract art from 1915 to 1937. First in Germany, then in the United States, he provided a link between European modernism and abstraction in the United States. *Fermented Soil,* completed a year before his death, is a churning picture about the fundamental natural process of decomposition.

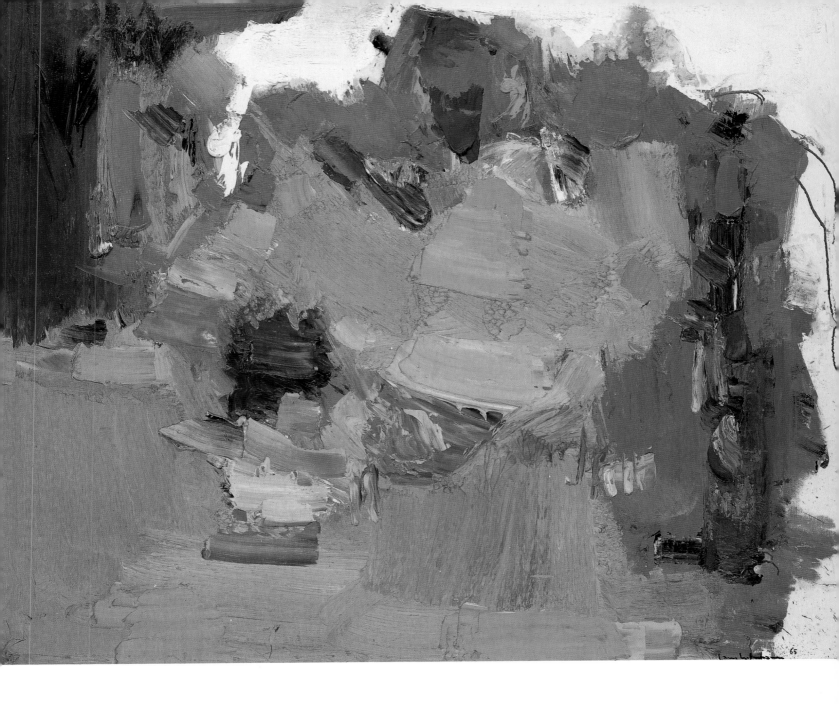

WILLIAM H. JOHNSON

1901–1970

Harbor under the Midnight Sun

1937, oil
71 x 95.3 cm
Smithsonian
American Art
Museum, Gift of the
Harmon Foundation

Harbor under the Midnight Sun explodes with vibrant aerodynamics and symbolist echoing of boats and houses in the reflections of the Norwegian fjord. This is an actual place, Svolvaer, with recognizable rock formations, but the harbor and surrounding mountains have been transformed by the hallucinatory intensity of the midnight sun and William H. Johnson's imagination. With bright colors and fairytale vitality, this painting represents a heightened sense of the Norwegian landscape where the artist lived and painted for five years.

Johnson appreciated Svolvaer harbor for its light, color, and majestic mountains. This is a romantic, empathetic landscape of sunlight, windswept blue skies, and gentle cloud cover.

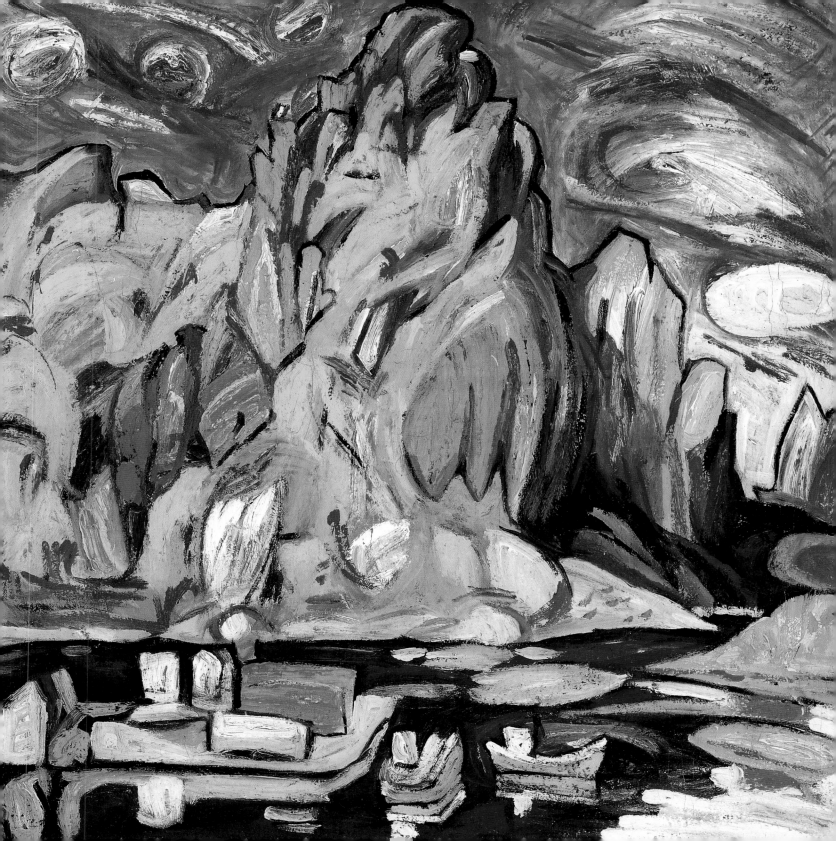

LOIS MAILOU JONES

1905–1998

Les Fétiches

1938, oil
64.7 x 53.3 cm
Smithsonian
American Art
Museum,
Museum purchase
made possible by
Mrs. N. H. Green,
Dr. R. Harlan, and
Francis Musgrave

Lois Mailou Jones painted *Les Fétiches* after she discovered African masks for the first time in Paris. These icons of her heritage, each different in style and attitude, are floating in a shallow space as in a dream, hovering on the edge of consciousness. They evoke the memory of the past, with the central mask—perhaps that of a woman—at its center.

As we look more closely, we notice that some of the heads are looking back at us, fully engaging our attention, as if alive. Jones established an ominous tension between the striped mask and the curvaceous fetish figure. Strong patterns and bold streaks of light against the dark background intensify the mysterious mood, creating an image that is at once confrontational and contemplative.

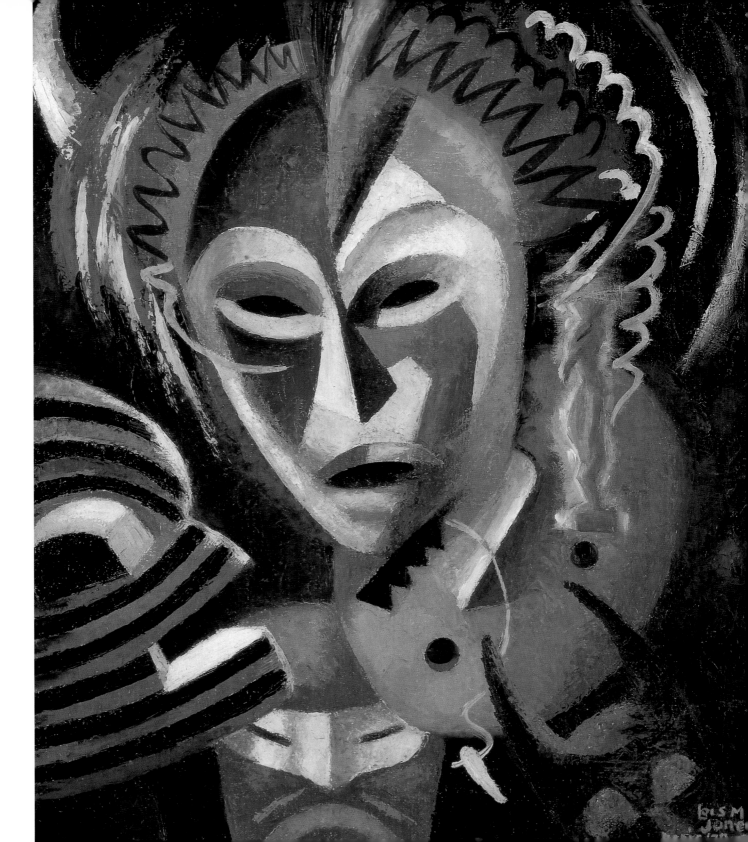

JACOB KAINEN

born 1909

Dabrowsky V

1986, oil
203.2 x 254 cm
Smithsonian
American Art
Museum,
Gift in honor of
Adelyn Dohme Breeskin
from her friends

Jacob Kainen named this painting after a very good friend and fellow artist John Graham, who was known as Ivan Dabrowsky in Russia before immigrating to the United States. With colors reflecting Graham's Russian palette, the soft-edged geometric shapes, according to Kainen, stand for Graham's "austere magical personality." The dynamic positioning of shapes, balance, and massing reflect Graham's intense personality.

Dabrowsky V is one of an occasional series with similar forms in different colors, sizes, and proportions. The soft colors and simple geometric shapes, arranged at purposeful intervals, establish harmony. The indeterminate identities of these forms allude to the mysterious symbols Graham used in his paintings.

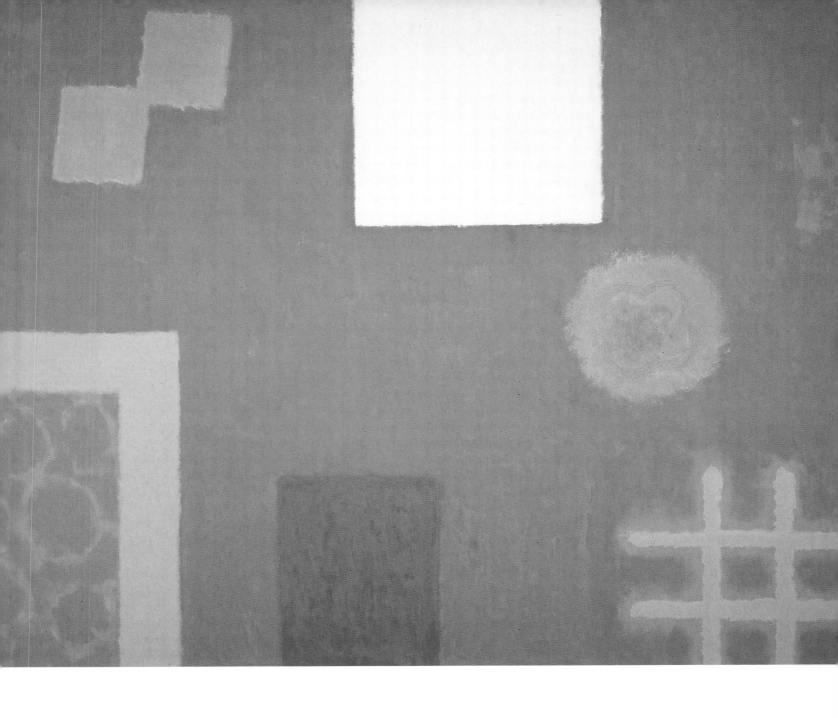

ELLSWORTH KELLY

born 1923

Blue on White

1961, oil
217.5 x 172.1 cm
Smithsonian
American Art
Museum, Gift of
S. C. Johnson
& Son, Inc.

A broad blue shape floats like a balloon. It is a biomorphic shape, natural in origin, simple, flat, upright, and voluptuous. There is humor in the way the bulbous area balances precariously on the thin, tail-like base. The loose, layered brushwork that defines this weightless shape contradicts the fixed definition given by the hard edge of its color. Wondering what this icon represents, we remember the game of looking for recognizable images in cloud formations. In fact, the image began as an apple, with stem, turned on its side. It became a painting about the relationship between two colors.

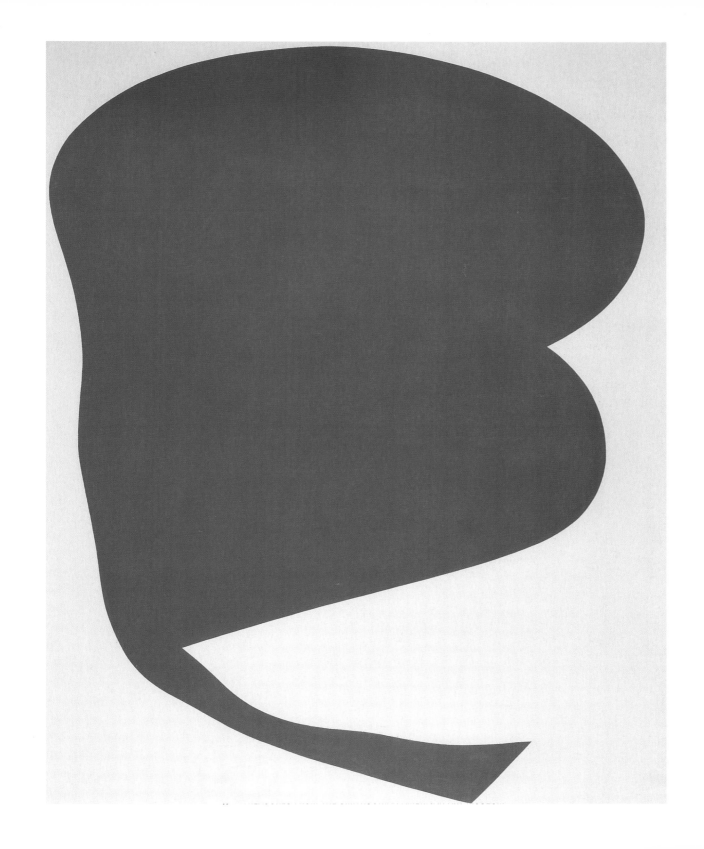

FRANZ KLINE

1910–1962

Merce C

1961, oil
236.2 x 189.4 cm
Smithsonian
American Art
Museum, Gift of
S. C. Johnson
& Son, Inc.

Franz Kline's *Merce C* is an emblem of power and strength, perfectly placed within the pictorial field, just off center. From central points of energy, broad-brushed emphatic gestures spread out in all directions, stabilized by upward thrusting vertical strokes of black paint.

The painting is an abstract portrait of the artist's friend, dancer and choreographer Merce Cunningham. It conveys Cunningham's strength and the dynamic force of his body as he moves through space. Despite the fast-slashing brush strokes, the painting is a classically balanced composition.

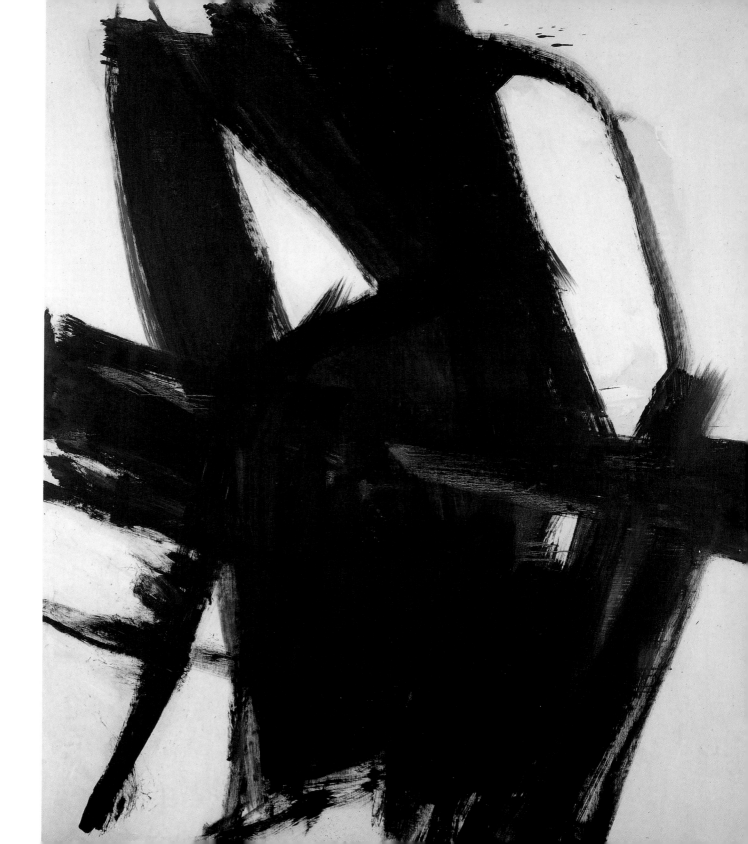

LEE KRASNER

1908–1984

Composition

1943, oil
76.5 x 61.6 cm
Smithsonian
American Art
Museum,
Museum purchase
made possible by
Mrs. Otto L. Spaeth,
David S. Purvis, and
anonymous donors
and through
the Director's
Discretionary Fund

An animated anthropomorphic figure fills Lee Krasner's cheerful composition of cubist circles, triangles, and parallelograms. The jaunty juggling of primary colors and basic geometric shapes keeps our eyes moving across the canvas, while the black skeletal structure stabilizes the composition. Krasner took the principles of cubist deconstruction and turned them around to build pictures with down-to-earth energy.

Although she spent many years furthering the career of her husband, Jackson Pollock, at the expense of her own, Krasner was a significant member of the generation that translated French cubism and surrealism into a distinctly American, more emotionally expressive abstract form.

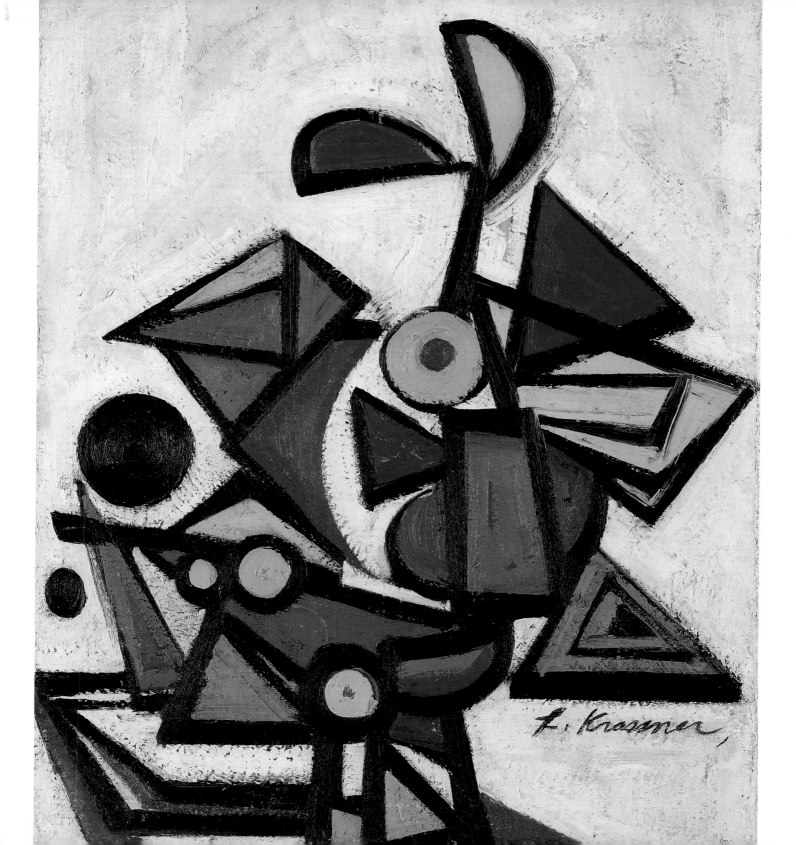

F. Kraemer

NORMAN LEWIS

1909–1979

Evening Rendezvous

1962, oil

127.7 x 163.3 cm

Smithsonian
American Art
Museum

Evening Rendezvous is almost impressionist in its stippled blocks of color and diffusion of form. Looking closer, we see this is not a pastoral landscape. It is a bird's-eye view of a Ku Klux Klan gathering. The dominant colors are red, white, and blue. Does the red area signify burning campfires or symbolize flowing of blood?

Norman Lewis was a committed political activist in the Civil Rights movement. Having first painted in a social realist style, he turned to nonrepresentational art before many other members of the New York School. He was friends with the abstract expressionist artists and was a force in the Harlem Renaissance. Lewis evolved a distinct style of atmospheric color and calligraphic markings that often symbolize crowds of people involved in rituals, sometimes identified by titles affirming his social consciousness.

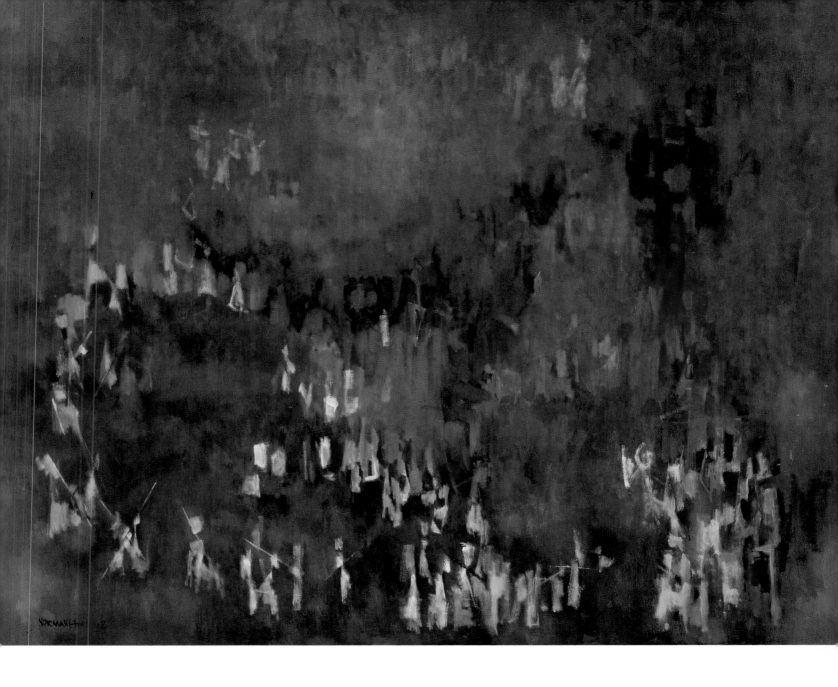

MORRIS LOUIS

1912–1962

Faces

1959, acrylic
231.8 x 345.5 cm
Smithsonian
American Art
Museum,
Museum purchase
from the Vincent
Melzac Collection
through the
Smithsonian
Institution Collections
Acquisition Program

In Morris Louis's *Faces,* paint seems to flow down the canvas like a waterfall. Adapting Jackson Pollock's technique of pouring paint, Louis soaked unprimed canvas with thin washes of acrylic paint. The subtly shifting colors are given final shape by Louis's decision about precisely where to cut the canvas surrounding the image, before stretching it on a frame.

Looking through the diaphanous layers of *Faces* elucidates the process of the work's making, rather than telling a story or showing a scene. Louis's abstraction was based on color. In the 1950s he was a leader of the Washington Color School, whose members included Gene Davis, Kenneth Noland, Paul Reed, Thomas Downing, and Howard Mehring.

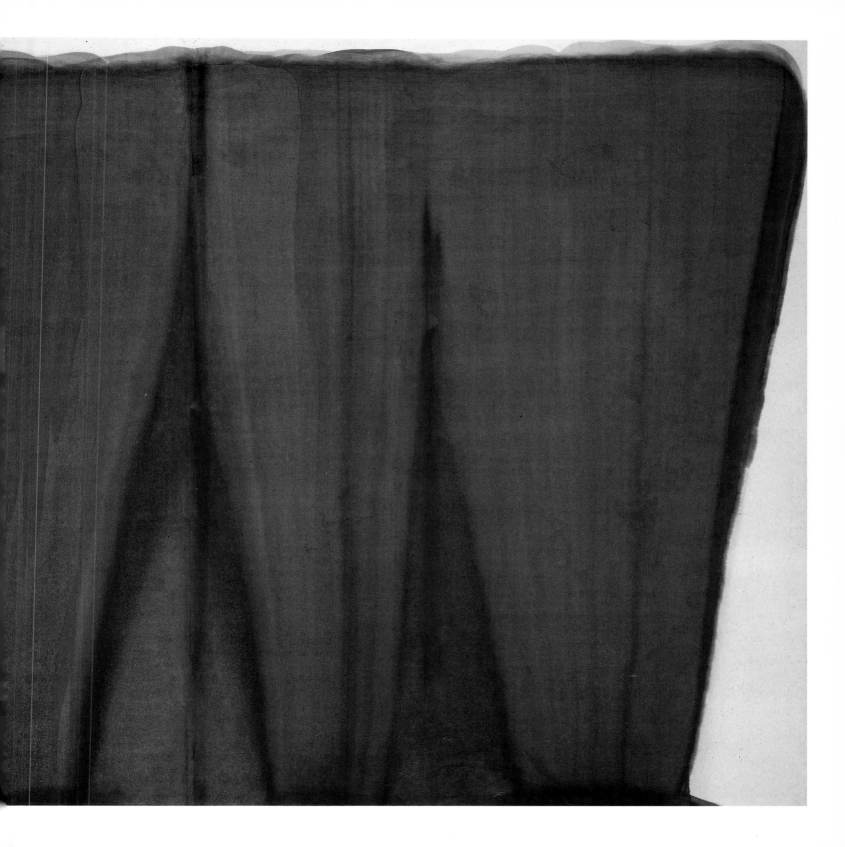

JAN MATULKA

1890–1972

Arrangement with Phonograph, Mask, and Shell

about 1930, oil
77.2 x 89.5 cm
Smithsonian
American Art
Museum

Arrangement with Phonograph, Mask, and Shell is one of a number of paintings of the same subject that Jan Matulka executed in a postcubist style. The lively characterization of the still-life forms reveals a familiarity. Focussing on exotic objects that lead the mind beyond the confines of the room, Matulka arranged an encounter among the then-fashionable African mask, then-modern phonograph, and a large seashell.

A significant figure in the New York art world of the 1920s and 1930s, Matulka regularly brought the latest ideas about modern art home from Paris to teach at the Art Students League. With its bright colors, patterned abstractions, and curvilinear silhouettes, this tabletop still life is thoroughly modern. Hard-edged color areas sometimes designate discrete objects and sometimes are just abstract shapes that enliven the simple scene with stylish wit.

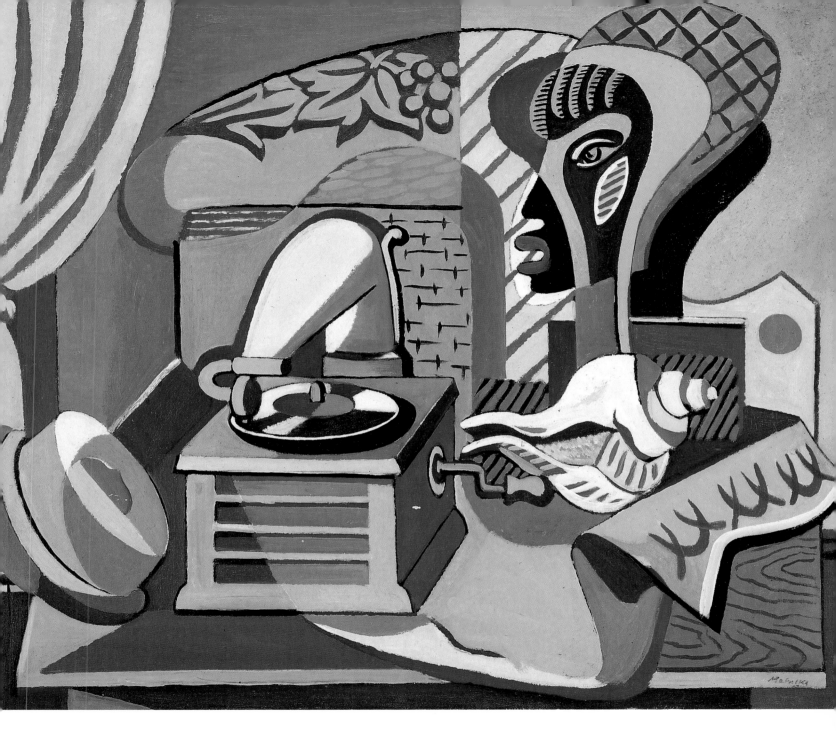

JOAN MITCHELL

1926–1992

Marlin

1960, oil
241.3 x 180.3 cm
Smithsonian
American Art
Museum, Gift of
S. C. Johnson
& Son, Inc.

Joan Mitchell's landscapes and seascapes are abstractions of the colors, patterns, and rhythms of the natural world that surrounded her in Long Island and in the south of France. We seem to look down and through layers of color, much the way Mitchell might have looked down into the ocean when deep-sea fishing. The broad slashing strokes of deep color in the picture's center contrast with the more delicate white lines and brighter tones as the imagery spreads outward. With well-practiced pictorial intelligence, Mitchell shaped the evident spontaneity of the painting into a visual composition of classical elegance.

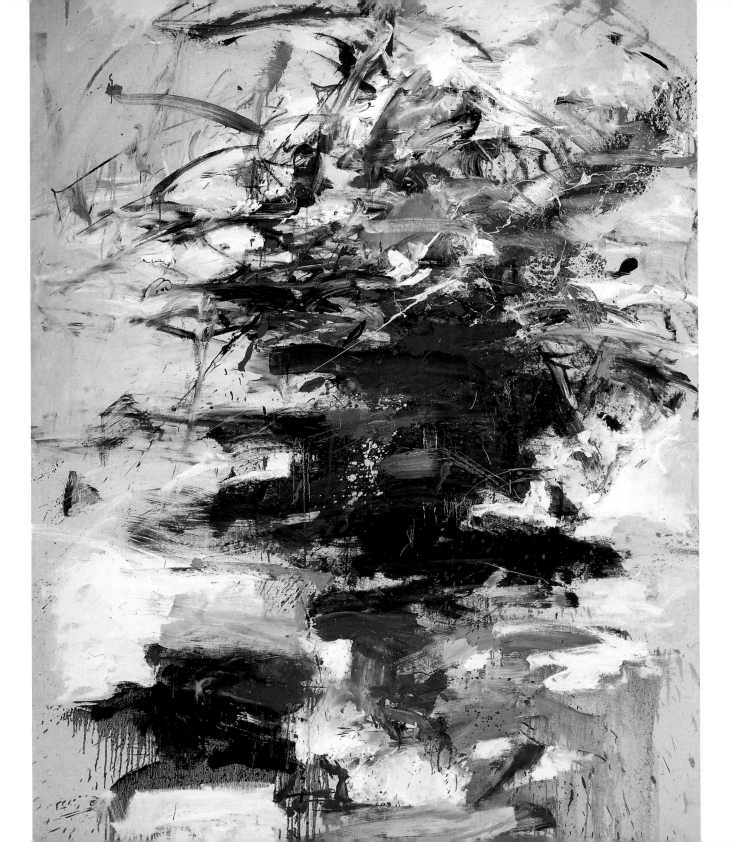

LÁSZLÓ MOHOLY-NAGY

1895–1946

Leuk 5

1946, oil
76.9 x 96.5 cm
Smithsonian
American Art
Museum, Gift of
Patricia and
Phillip Frost

A utopian thinker, theoretician, and polymath, László Moholy-Nagy believed that modern art and technology could save society following the devastation of World War I. He came from Germany to the United States in 1937 and became a prolific artist and influential teacher. He joined the American Abstract Artists in 1939, contributed to their journal, and exhibited regularly with them.

Leuk 5 has been described as an autobiographical painting reflecting Moholy-Nagy's ambivalence about nuclear science. Just a year after the atom bomb unleashed new levels of destruction, scientists developed new radiation treatments for his leukemia. Red, black, and white disks suggesting molecular structures and gyroscopes float in a realm where inner and outer space form an ambiguous dimensional continuum.

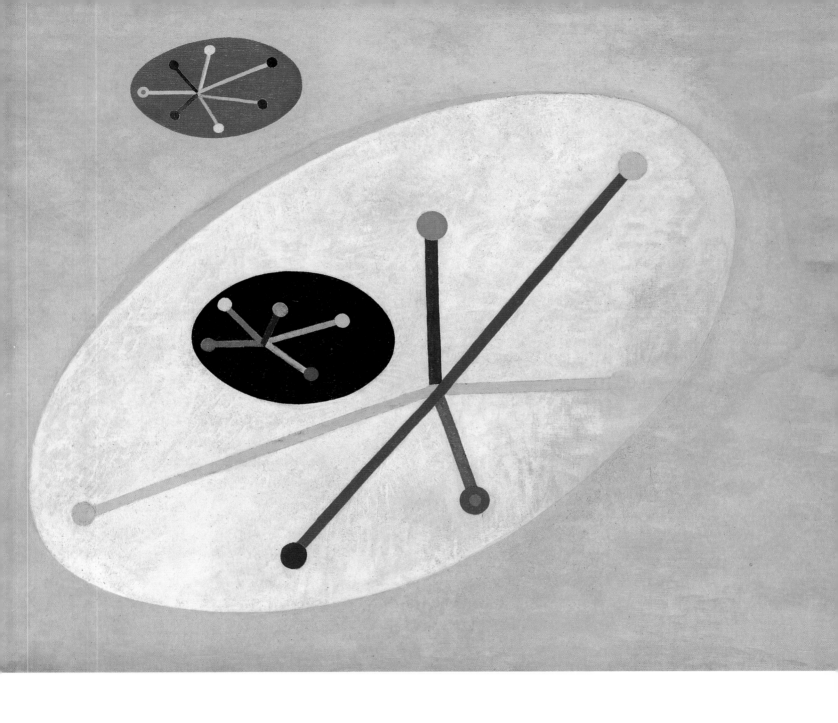

GEORGE L. K. MORRIS

1905–1975

Ascending Space

1946, gilded bronze
on stone base
67 x 110.2 x 58.7 cm
Smithsonian American
Art Museum

Although better known for his paintings, George L. K. Morris produced sculpture at regular intervals from 1935 to 1956. Variously realized in stone, bronze, cement, and plaster, these three-dimensional works had in common projecting triangular or pyramidal forms.

Ascending Space is a heroic sculpture that celebrates advances in flight. It joins the images of an American Indian arrow and an abstracted airplane in a modern vision. While the trajectories of the forms are dynamic, the three triangles suggest a classic trinity, linked by the gracefully curving arc.

A founding member of the American Abstract Artists, influential critic for the *Partisan Review,* and Suzy Frelinghuysen's husband, Morris developed a personal kind of abstraction from studying the formal simplifications of Native American art and design, as well as from Parisian cubism.

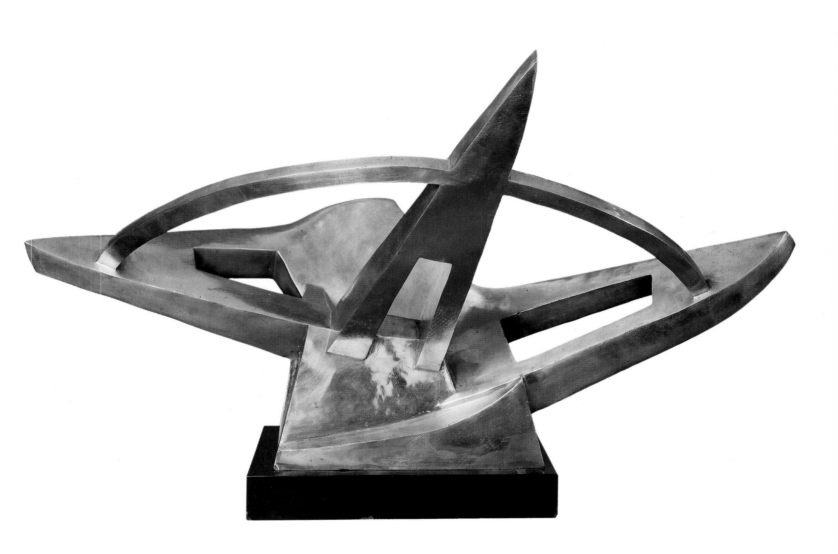

ROBERT MOTHERWELL

1915–1991

Monster (for Charles Ives)

1959, oil
198.8 x 300.4 cm
Smithsonian
American Art
Museum, Gift of
S. C. Johnson
& Son, Inc.

Robert Motherwell conjured up this imposing monster while listening to the music of Charles Ives, an experimental twentieth-century composer whose originality inspired many modern artists. Reminiscent of hulking shadows cast on the wall by a glowing fire, and of the nightmare visions that Goya painted on his dining room walls, this monumental beast is earth-toned, merging with the landscape, and dominating the horizon. The monster's eye—which seems to be watching us—targets our attention in the painting. Motherwell's bold brushwork, highly saturated color, and the harsh contrast between dark and light create a monumental image.

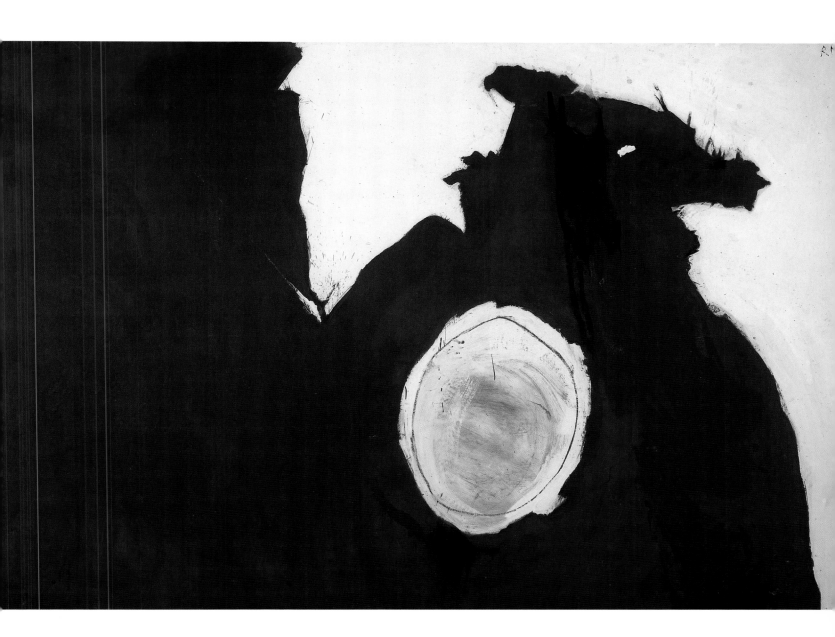

ISAMU NOGUCHI

1904–1988

Grey Sun

1967, marble
102.5 x 100 x 42.8 cm
Smithsonian
American Art
Museum,
Gift of the artist

Isamu Noguchi made visible the basic forms and forces of nature, using natural materials and fundamental shapes. The marble in *Grey Sun* expresses its connection to the earth and gravity through its evident weightiness. Noguchi frequently used the circle as a timeless, universal symbol, related to the sun, origin of life, and basis of numerical systems. In *Grey Sun,* the continuous energy of this form gains emotional resonance from the contrast between rough and smooth polished surfaces. This ring is not a perfect circle, but dynamically balanced, transformed by the artist's hand and mind.

Son of a Japanese father and American mother, Noguchi worked in both Japan and New York, synthesizing Eastern and Western ideas and combining tradition and modernism. *Grey Sun* represents the paradox of fullness and emptiness, being and nothingness.

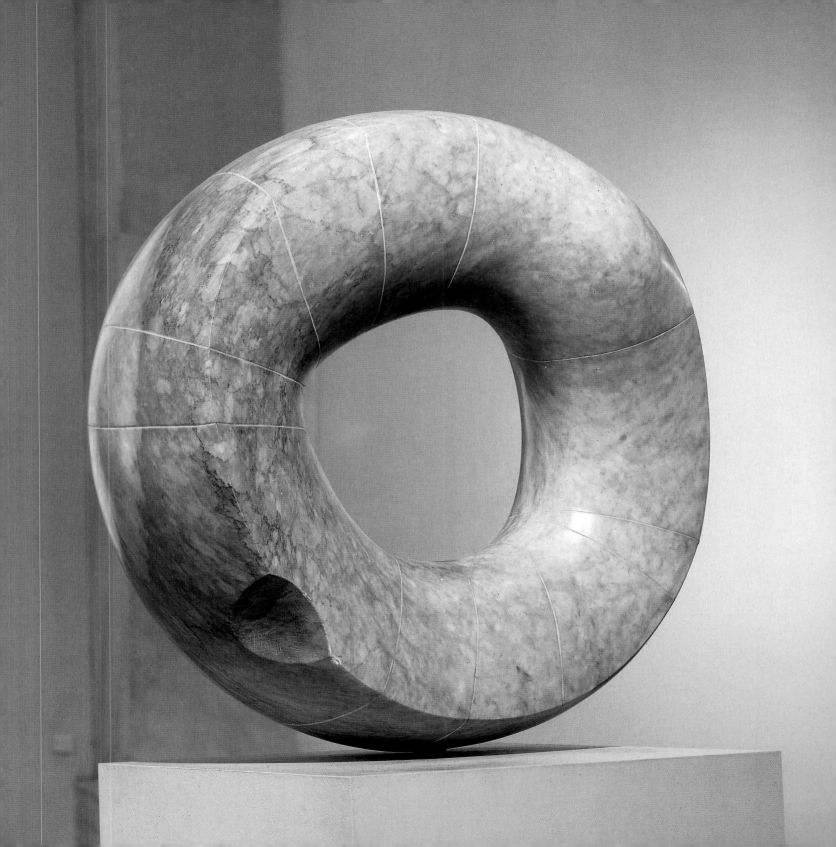

KENNETH NOLAND

born 1924

Split

1959, acrylic
237.8 x 238.5 cm
Smithsonian
American Art
Museum, Gift from
the Vincent Melzac
Collection

Split is a virtuoso balancing act of a diamond, containing a circle, floating in a circular space, surrounded by three circular bands. The stained colors are dynamic, and the rings and diamond appear to recede and advance.

Kenneth Noland believed that "color can be mood, can convey human meaning." In *Split,* the colors are both harmonious and dissonant, their relationships and ratios carefully determined. *Split* is one of two hundred Circle paintings that he painted between 1956 and 1963. A member of the Washington Color School, Noland was a leader of the color field abstraction movement of the 1950s and 1960s. In all his paintings, the logic and interaction of geometric forms are balanced with the celebration of pure color.

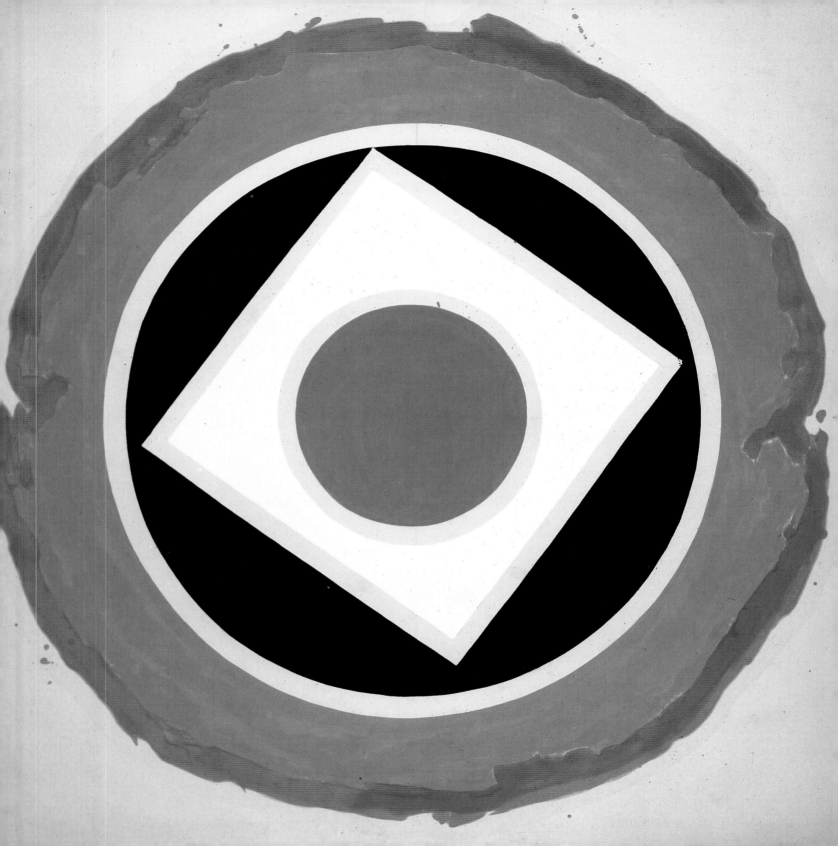

GEORGIA O'KEEFFE

1887–1986

Untitled (Manhattan)

1932, oil
214.3 x 122.4 cm
Smithsonian
American Art
Museum, Gift of the
Georgia O'Keeffe
Foundation

Untitled (Manhattan) is Georgia O'Keeffe's only mural painting. It presents the dizzying heights, soaring verticals, and spectacular views of New York's skyscrapers, which she captured in more than twenty scenes. O'Keeffe not only painted these wonders of modern technology, she was one of the first artists to reside in one. In the mid-1920s, she and her husband, photographer and gallery director Alfred Stieglitz, had an apartment on the thirtieth floor of the Shelton Hotel.

Created for the Museum of Modern Art's grand opening exhibition in 1932, *Untitled (Manhattan)* is composed of dazzling patterns of white, black, and pink that suggest varying skyscrapers as they rise, clifflike, against a bright blue sky. The multidirectional diagonals reinforce the energy of the colors. As if to humanize the sharp-edged urban setting, O'Keeffe added roses, prefiguring the close-up representation of flowers that would become one of her signature images.

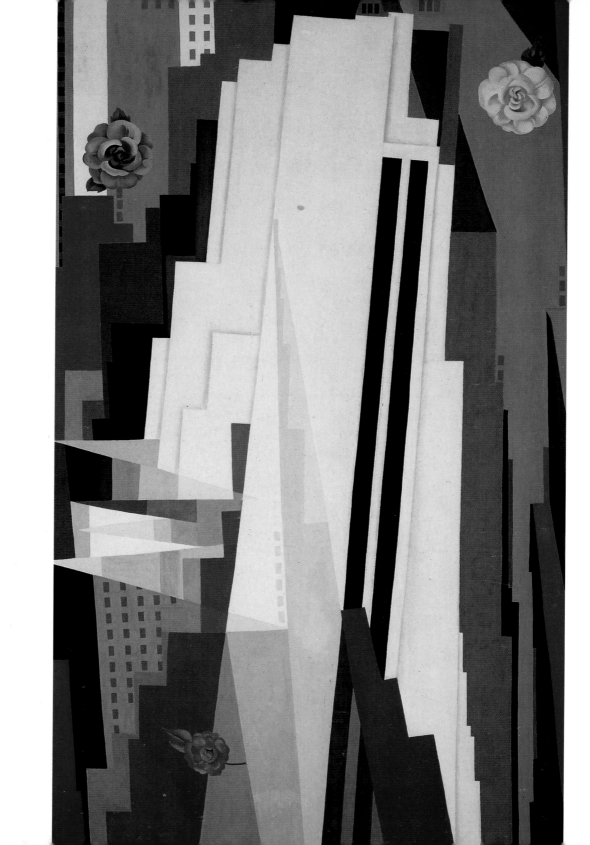

NATHAN OLIVEIRA

born 1928

Nineteen Twenty-Nine

1961, oil

137.4 x 127.2 cm

Smithsonian
American Art
Museum, Gift of
S. C. Johnson
& Son, Inc.

Nineteen Twenty-Nine is at once a subjective portrait of a woman and an image of the artist's mother, painted from memory. The figure, in 1920s clothes, is dissolved by space and precariously perched on a single-legged stool. The brown background and black-and-blue floor, together with the contrasting colors of the figure, her off-center placement, and the gestural brushwork, produce a somber, haunting image. The work takes on added meaning for Oliveira in the date 1929, which is scratched into the paint at the lower right of the canvas. One year after his birth, the stock market crashed and his family met with financial ruin.

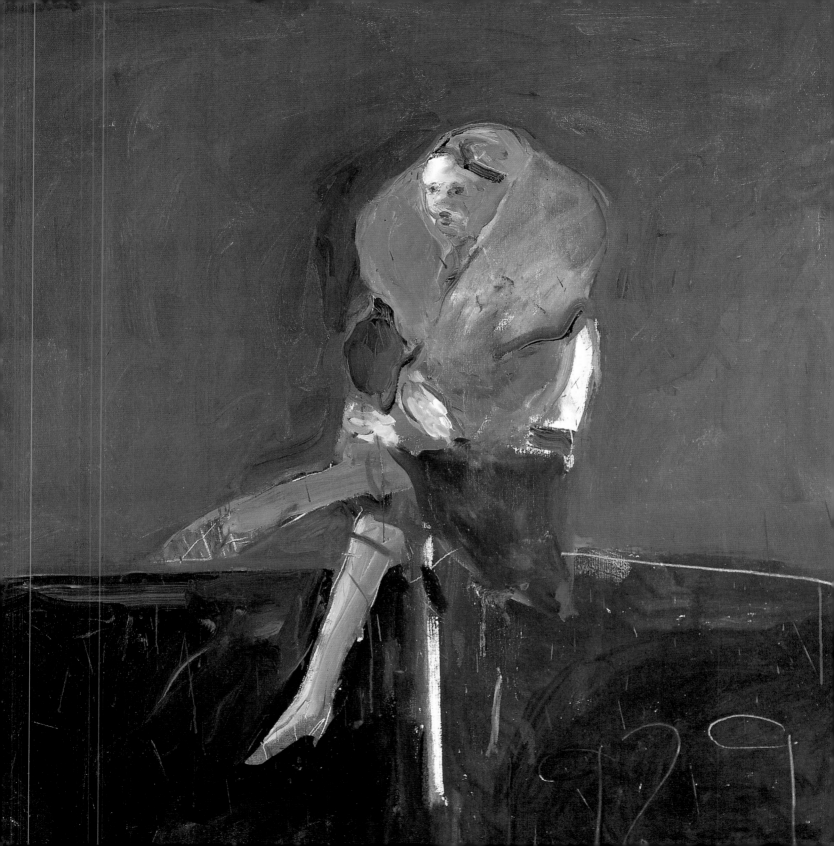

BEVERLY PEPPER

born 1924

Ternana Altar, II

1991, cast iron with
fabricated steel base
234.6 x 120 x 67.6 cm
Smithsonian
American Art
Museum, Gift of
the artist and
museum purchase
made possible by
J. B. Chadwick

Ternana Altar, II is part of a series of what the artist calls "urban altars," monumental objects that evoke ritual and mystery through their massiveness.

Beverly Pepper was inspired to become a sculptor by the temples of Angkor Wat in Cambodia and lived for a time in Italy, surrounded by antique and medieval ruins. She has been concerned throughout her career with archetypal forms suggestive of ceremony. "I wish to make an object that has a powerful presence," Pepper explains, but one that is "at the same time inwardly turned, seemingly capable of intense self-absorption." Her ambition is to create richly associative monuments for her own age through which the past is linked to the future. *Ternana Altar, II,* monumental in scale and covered with an earthy patina, reveals a trace of the artist's hand in its textured surface.

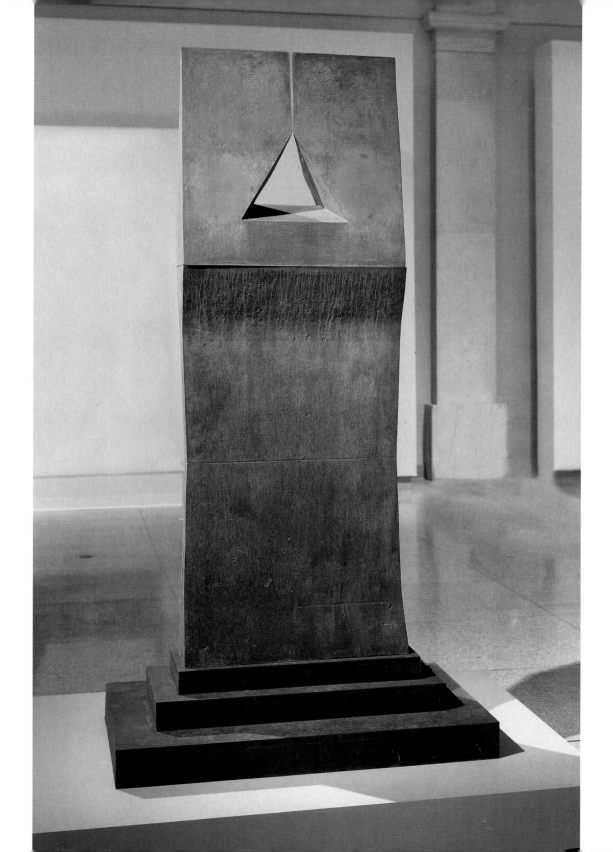

I. RICE PEREIRA

1902–1971

Machine Composition #2

1937, oil
122.5 x 152.4 cm
Smithsonian
American Art
Museum, Gift of
Patricia and
Phillip Frost

Machine Composition #2, a cheerful picture of the industrial world, derived from I. Rice Pereira's view of New York's 16th Street powerhouse, transformed into a fantasy rooftop cityscape. We recognize a glass brick skylight, windows, and pipes, but most of the forms, including the humanoid figure, are imaginary.

In the late 1930s, Pereira painted machine-age imagery to celebrate her belief in art's social function and in technological innovation and transcendental thinking. A theoretician as well as an artist, Pereira saw abstract art as a means of experimentation that would inform architecture, design, and photography.

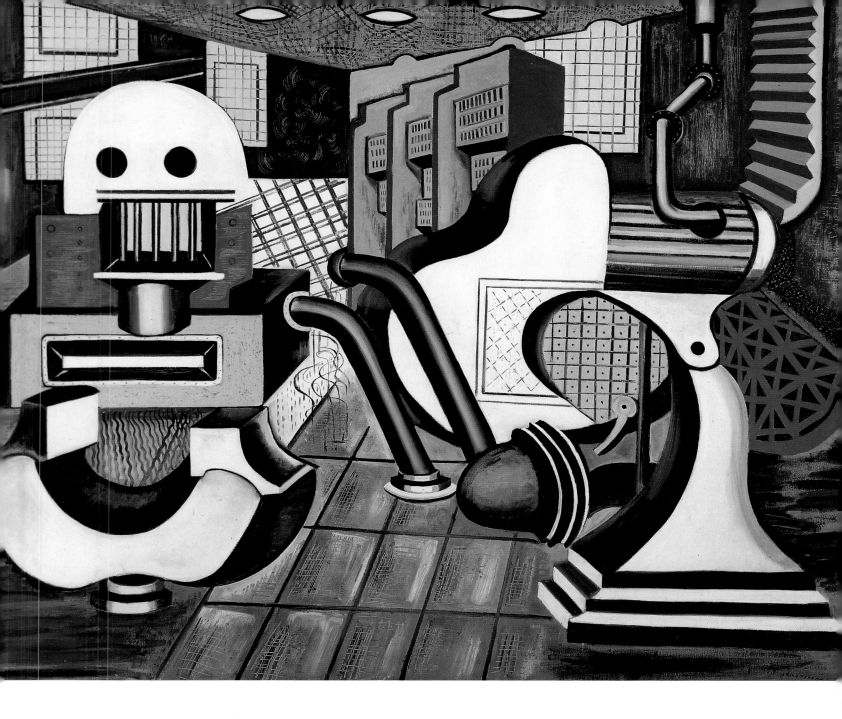

RICHARD POUSETTE-DART

1916–1992

White Gothic No. 5

1961, oil
194.3 x 142.9 cm
Smithsonian
American Art
Museum, Gift of
S. C. Johnson
& Son, Inc.

The abstract tracery of color in Richard Pousette-Dart's *White Gothic No. 5* evokes the delicate stone carving of Gothic architecture, the shimmering designs of stained-glass windows, and the Rouen cathedral paintings of Claude Monet, as well as the medieval manuscripts that the artist had studied. The dematerialization of form and allover pictorial configuration evoke a contemplative quality reflecting his spiritual intentions. The artist believed that the universe has "no certain points of beginning nor completion . . . no separate inside nor outside."

Pousette-Dart created a rich surface by building up the paint with brushes, knife, and spatula. He started with a lower layer, thinly applied to the canvas. Then he squeezed paint directly from the tube, not blending but shaping it into hollows and mounds that capture and reflect light.

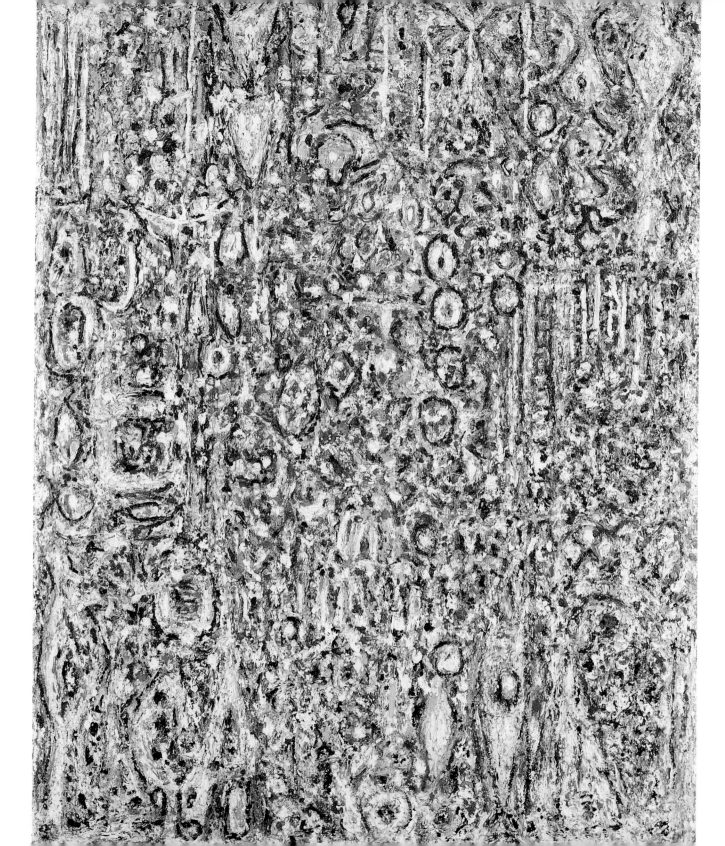

ROBERT RAUSCHENBERG

born 1925

Reservoir

1961, oil, wood,
graphite, fabric,
metal, and rubber
217.2 x 158.7 x 39.4 cm
Smithsonian
American Art
Museum, Gift of
S. C. Johnson
& Son, Inc.

Reservoir represents a high point in Robert Rauschenberg's "combine" paintings, works that merge materials and ideas drawn from the world of painting and the stuff of ordinary life. Found objects are arranged in seemingly accidental relationships and then united through the application of paint, allowing Rauschenberg to eliminate the distinction between art and life.

Created in 1961, during a period of collaboration between the artist and Merce Cunningham's dance company, *Reservoir* reveals Rauschenberg's interest in art as an ongoing process. The clock at upper left records the hour he began the painting, while the one at lower left was set when the painting was finished. The clocks are typical of the multiple references of Rauschenberg's objects; they appear to be normal timepieces but also record an interval directly pertinent to the painting as a work of art.

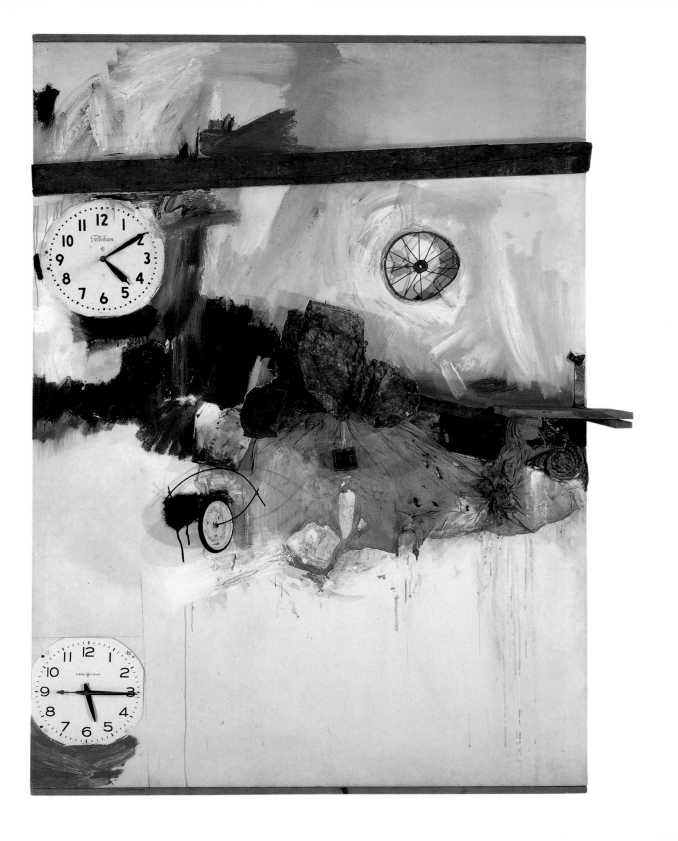

PAUL REED

born 1919

#1D

1965, acrylic
172.8 x 237.7 cm
Smithsonian
American Art
Museum, Gift of
Robert Reed

Paul Reed worked on the floor while executing this canvas. He soaked water-soluble acrylic paint into unprimed canvas so that color and canvas became one. His approach celebrated the aesthetic of truth to materials and the belief that art should refer to itself and to the process of its making. This purist approach to abstraction was a recurring tradition throughout the twentieth century.

In *#1D,* the highly saturated colors, with carefully calculated relationships among their hues, are formed so that the centered brown circle is visually suspended in the deep red hexagonal field, producing powerful retinal effects.

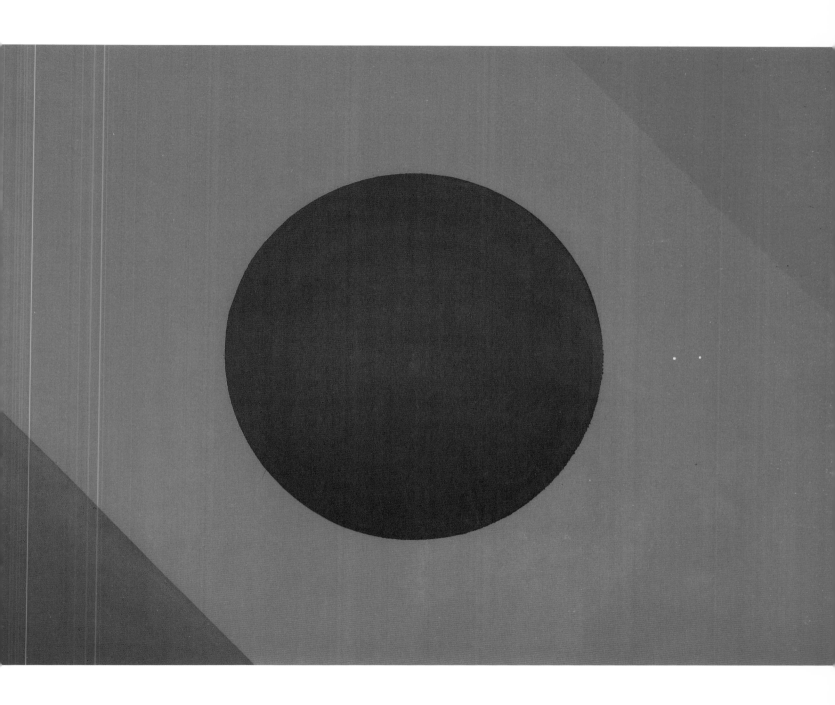

AD REINHARDT

1913–1967

Untitled

1940, oil
116.8 x 61 cm
Smithsonian
American Art
Museum, Gift of
Patricia and
Phillip Frost

In this small oil painting on wood, Reinhardt exploded Piet Mondrian's horizontal and vertical grids in many directions. His nonparallel arrangements of rectangles are more visually complex, more dynamically balanced, and open-ended in the interrelationships of forms and interactions of nonprimary colors. There is a spatially syncopated relationship among the bright hues (blues, pink, yellow, and red) and the earthy tones (browns, orange, dark green, and black).

Reinhardt's geometric abstraction is only about art, without literary, social, or political references. Fully knowledgeable about all modern art movements, he created work that was based on the belief that abstraction was a "new attempt to separate and define art. . . . In the twentieth century the central question in art is the purity of art."

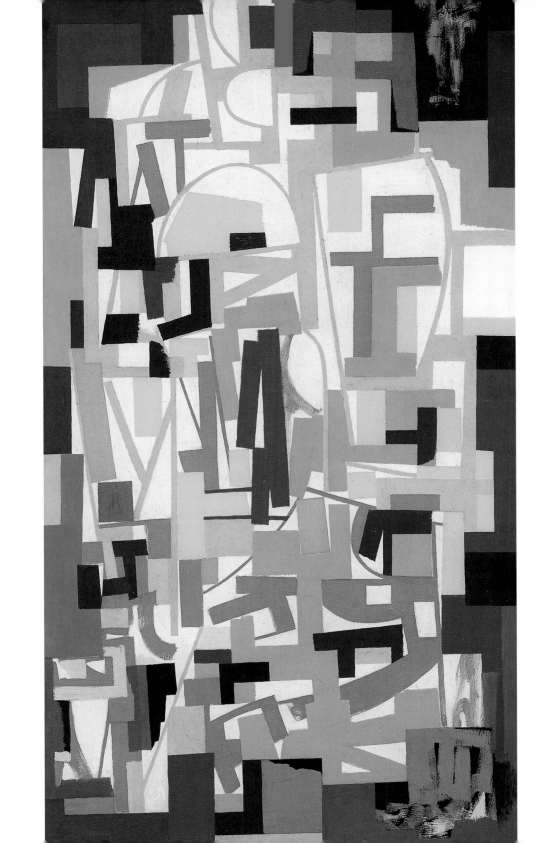

LARRY RIVERS

born 1923

The Athlete's Dream

1956, oil
208.7 x 301.8 cm
Smithsonian
American Art
Museum, Gift of
S. C. Johnson
& Son, Inc.

The Athlete's Dream combines fantasy and realism, revealing Larry Rivers's interests in traditional art history and vernacular imagery, drawing and painting. Convened in an array of candid poses and casual, mismatched dress is a team composed of the artist, his friends and family. Rivers leans out engagingly toward us at left center; the upper left of the painting offers four perspectives of writer Frank O'Hara, cigarette dangling from his lip; and the artist's mother-in-law, Berdie Burger, in triplicate, occupies the right half of the painting.

Rivers delineates the figures' faces and anatomy while rendering other areas in sweeping gestures of color. The smudged deletions and multiple overlapping views suggest the temporal and spatial shifts experienced in dreams as well as the blurring of figures in action.

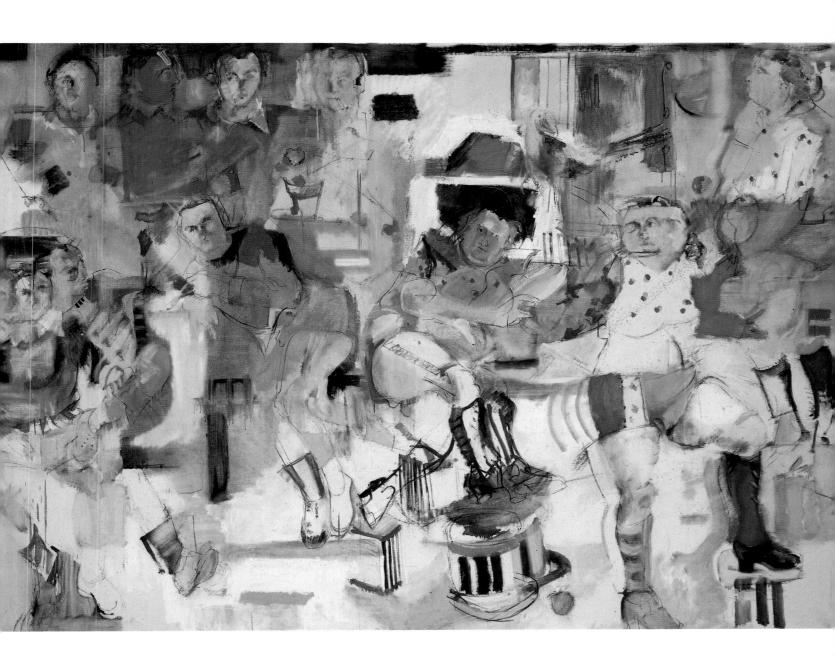

THEODORE ROSZAK

1907–1981

Recording Sound

1932, plaster
and oil on wood
81.3 x 121.9 x 17.1 cm
Smithsonian
American Art
Museum

Recording Sound combines painting and sculpture in a unique way. A three-dimensional plaster stage projects from the canvas plane to a depth of about three inches. It's a miniaturized opera performed for the modern miracle of the phonograph. An accomplished violinist, Theodore Roszak encompasses the world of live performance within the gramophone's trumpet, an operatic scene that presents sound's origin and transmission. A balloon, floating above the machine, is a metaphor for the transporting power of music. He also loved geometric forms and inscribed the image's mini-universe in a perfect circle, a form echoed throughout the composition.

Roszak was an industrial artist who appreciated modern technology and wanted to integrate the arts and industry. He based his art on the forms, materials, technology, scientific methods, and innovative spirit of the industrial age, developing a distinctive art form in which images of machines—symbols of modernism—represented contemporary America.

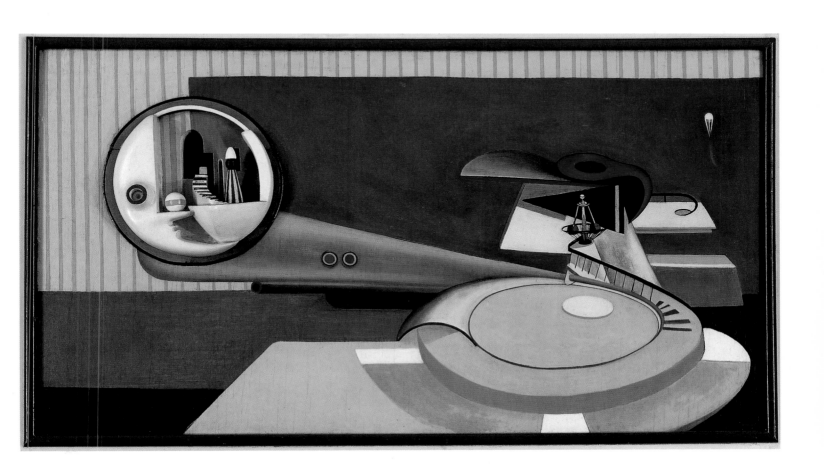

H. LYMAN SÄYEN

1875–1918

The Thundershower

about 1917–18
tempera
91.4 x 116.8 cm
Smithsonian
American Art
Museum, Gift of
H. Lyman Säyen
to his nation

Inventor of X-ray tubes and procedures, engineer of electrical instruments, commercial artist, oil painter, and graphic artist, H. Lyman Säyen went to Paris and brought the newest art back to Philadelphia.

The Thundershower is an energetic tableau that condenses indoor and outdoor views, with wallpapered walls and striped floors, into patterned and solid color planes. It reveals the influences of Säyen's perceptual experiments with a revolving disk. Creating his own version of futurism, Säyen made compositions that unfold like fans. Arabesques of color flatten the shallow, stagelike scene, their rhythms drawing our attention to the arcs of pink rain and curvaceous female bodies. *Thundershower* is filled with the joie de vivre that Säyen had absorbed from studying with Matisse.

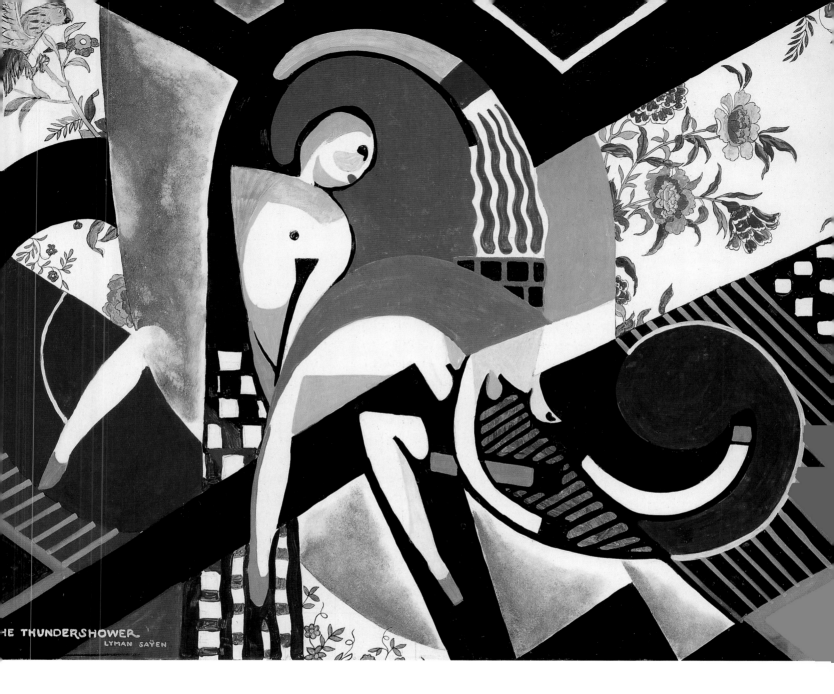

THE THUNDERSHOWER

LYMAN SAŸEN

ESPHYR SLOBODKINA

born 1908

Crossroad #2

about 1942–45, oil
110.5 x 85.1 cm
Smithsonian
American Art
Museum, Gift of
Patricia and
Phillip Frost

Esphyr Slobodkina's *Crossroad #2* has lively interrelationships of crossing, overlapping, rising, and supporting forms, almost as if they are dancing. The opaque colored shapes recall the torn papers of Slobodkina's collages of the previous decade, as well as cut fabrics and clothing patterns. In fact, this Siberian-born immigrant sometimes worked as a textile designer and printer, and was a successful author of children's books, as well as a painter.

An active member of the American Abstract Artists and the Artists' Union, Slobodkina participated in their discussions about the term "abstract art" as opposed to nonobjective and nonrepresentational art. She declared: "to me abstract art is an abstract of all the BEST QUALITIES OF GOOD PAINTING TRANSFERRED UNTO THE CANVAS WITHOUT THE CRUTCHES OF REALISTIC, SYMBOLIC or SOCIALLY SIGNIFICANT EVENTS."

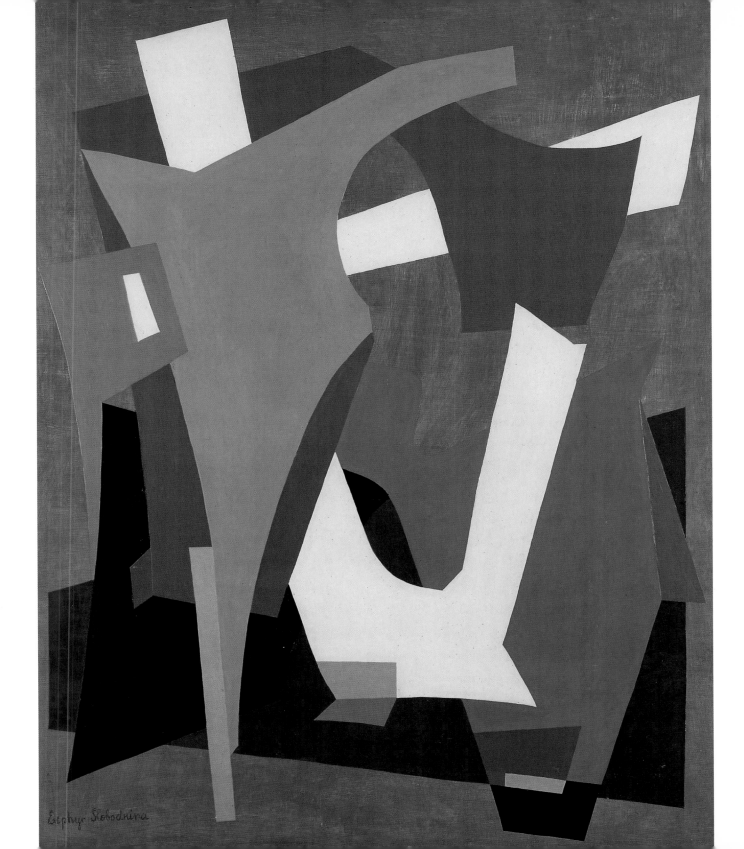

Zephyr Slobodkina

JOSEPH STELLA

1877–1946

Metropolitan Port

about 1935–37, oil
89.2 x 74.3 cm
Smithsonian
American Art
Museum,
Transfer from the
General Services
Administration

Awed by the wonders of the modern industrial age, Joseph Stella created visual tributes to their energy and power. He celebrated the Brooklyn Bridge and New York harbor in a number of paintings from 1916 to 1922 and at occasional intervals thereafter. In *Metropolitan Port,* the linear diagram of the cables is juxtaposed to the intersecting vertical and horizontal planes, making geometric visual poetry.

As a teenager in the 1890s, Stella emigrated to America from a small town near Naples. His fascination with harbors and bridges suggest his persistent interest in life-altering transitions. When this work was made in the mid-1930s, many Europeans were similarly seeking "safe harbor" in New York.

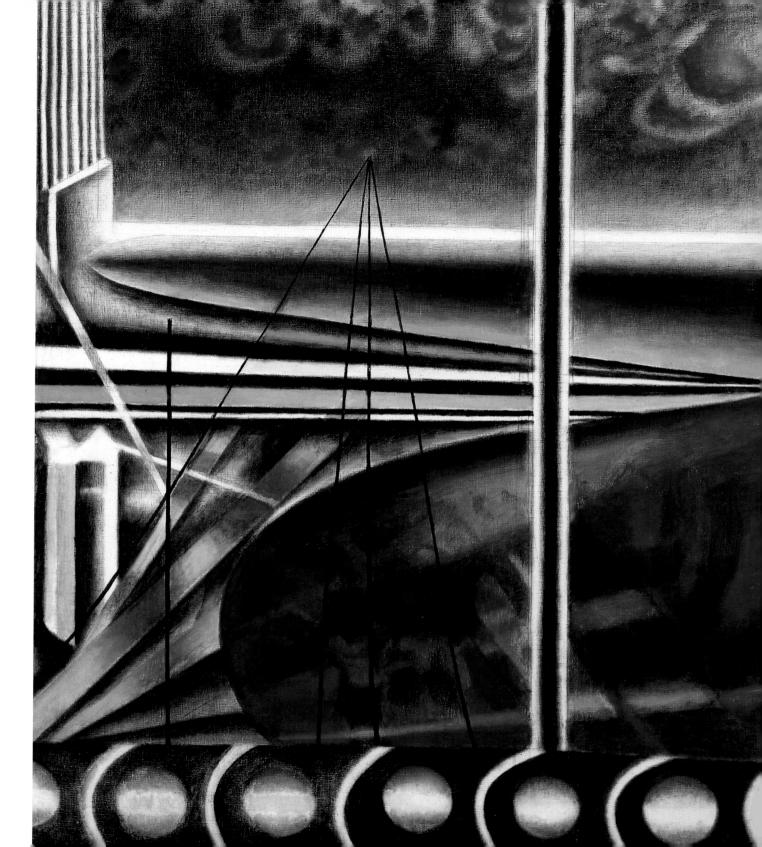

CLYFFORD STILL

1904–1980

1946–H (Indian Red and Black)

1946, oil
198.8 x 173.7 cm
Smithsonian
American Art
Museum,
Museum purchase
from the Vincent
Melzac Collection
through the
Smithsonian
Institution Collections
Acquisition Program

The rugged silhouette, crusty surface, and vast scale of Clyfford Still's paintings reflect his North Dakota homeland. In *1946–H (Indian Red and Black),* jagged flamelike forms, slashing streaks of black and white, and thickly painted intense colors create a dramatic panorama.

Still was a visionary artist committed to establishing a distinctly American aesthetic. In creating images of limitless scale, he conveyed a palpable sense of freedom.

Although Still was grouped with the abstract expressionist artists who were his friends, he always remained independent. He evolved a style that conveyed the sublimity of the American landscape, and he continued to paint romantic abstractions with similar imagery, in wildly different color combinations, until his death in 1980.

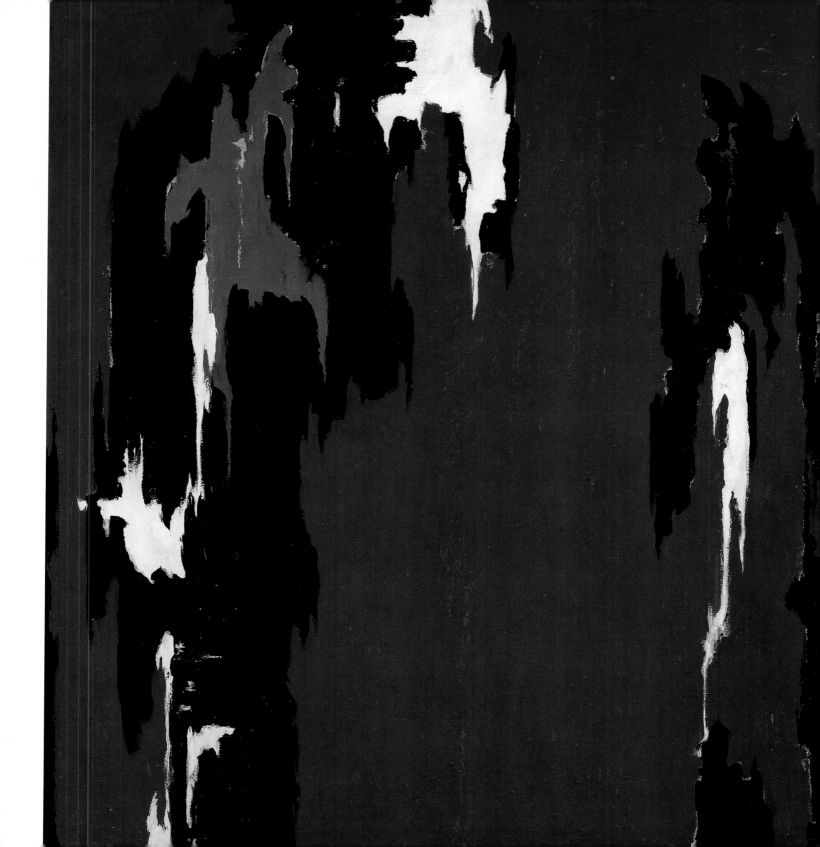

MARK TANSEY

born 1949

Interception

1996, oil
181 x 275 cm
Smithsonian
American Art
Museum,
Museum purchase
made possible by the
American Art Forum

Mark Tansey combines realism, intellectual theory, literary associations, and a sense of the uncanny to construct postmodern allegories. Striking contrasts of dark and light, great discrepancies of scale, and shifting perspectives dramatize the nocturnal scene in *Interception*.

We look at the scene as if it were a movie, peering into a charred landscape where figures struggle to control a billowing cloth. A giant beam of light illuminates the cloth, revealing images as projections and reflections. The figures allude to a Greek legend about the origin of art: Painting was invented when a young woman traced the silhouette of her lover, cast as a shadow by firelight onto a wall. The magic of representation is the theme of that myth and this painting.

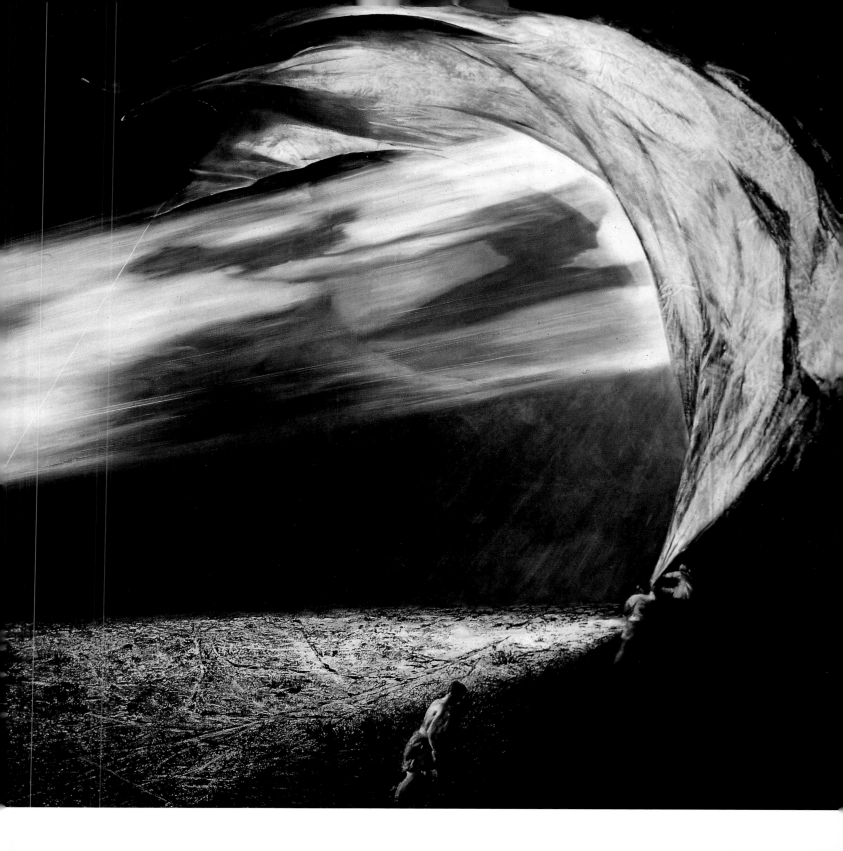

WAYNE THIEBAUD

born 1920

Jackpot Machine

1962, oil
96.5 x 68.3 cm
Smithsonian
American Art
Museum,
Museum purchase
made possible by the
American Art Forum
and gift of an
anonymous donor

Wayne Thiebaud's *Jackpot Machine* greets us with upraised arm and the promise of fortune. Its form recalls a triumphal arch or perhaps a robotic face with mechanical features. Deriving from the American still-life tradition and contemporaneous with pop art's veneration of everyday objects, this slot machine is both comic and heroic.

Lushly painted in red, white, and blue, and decorated with stars, *Jackpot Machine* represents a distinctly American dream. In spite of the bright colors and hearty form, there is a peculiar stillness to this painting as we wait for the arm to go down, the fruit to spin, and money to come clanking out of the machine's mouth.

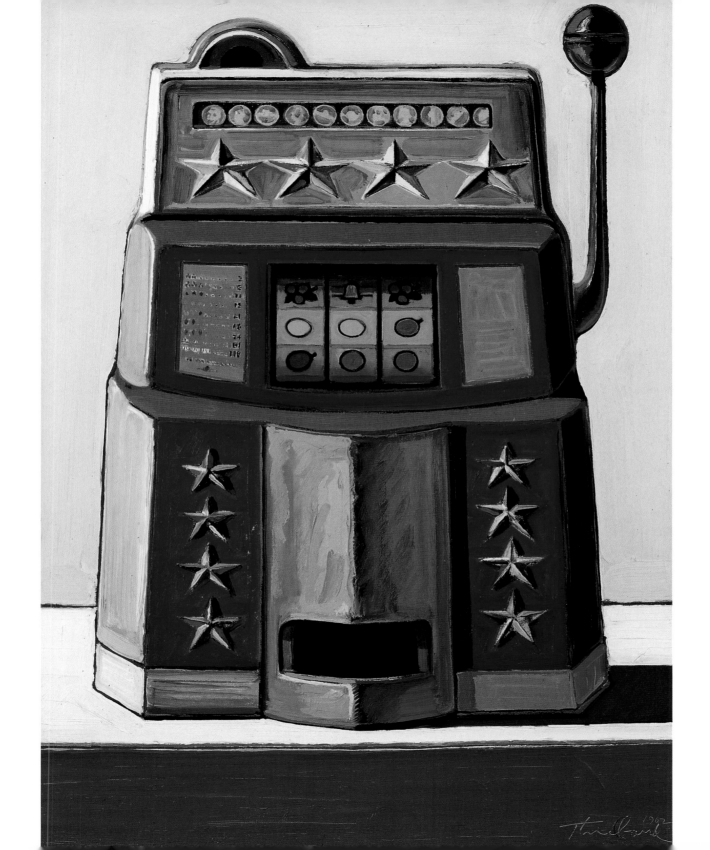

ALMA THOMAS

1891–1978

Red Sunset, Old Pond Concerto

1972, acrylic
175 x 134.5 cm
Smithsonian
American Art
Museum,
Gift of the
Woodward
Foundation

Red Sunset, Old Pond Concerto conveys the pulsing, piercing intensity of the setting sun. Rhythmic dark and light stripes, seen through broader bands of loosely brushed red, create a dynamic surface energy. The sensation of light saturation provides a strong sense of clarity.

From her Georgia childhood on, Alma Thomas responded to sounds and sights of nature together. She started making abstract paintings in her early sixties, after thirty-five years of teaching in a junior high school and painting like a cubist-influenced realist. She evolved her own color principles based on musical composition. Like many twentieth-century artists, she was also interested in theories linking music and nature as a basis for abstract art. Inspired by intimate observation of flowers and trees, Thomas painted abstract patterns of light seen through foliage, believing that "light reveals the spirit or living soul of the world through colors."

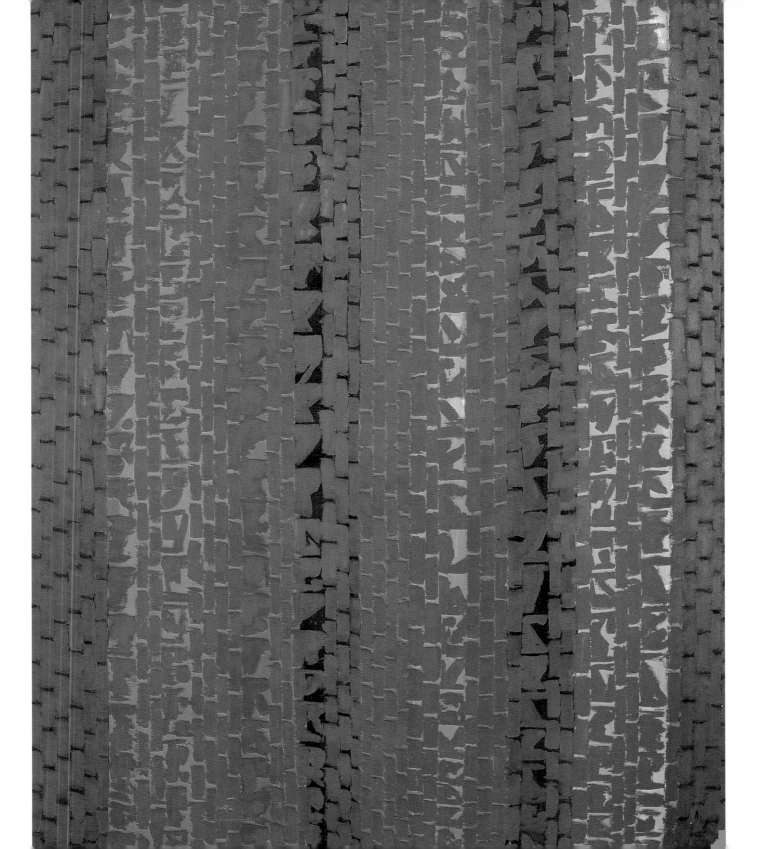

BOB THOMPSON

1937–1966

Enchanted Rider

1961, oil
159.5 x 119 cm
Smithsonian
American Art
Museum, Gift of
Mr. and Mrs. David K.
Anderson,
Martha Jackson
Memorial Collection

Enchanted Rider is an apocalyptic image that commingles Greek mythology (the enchanted horse Pegasus with rider Bellerophon defeating the chimera) with Christian religious imagery (saints on horseback trampling the devil).

Influenced by old-master paintings, which he traveled widely to see, Thompson absorbed Piero della Francesca's figural flatness, Poussin's space, and the dramatic distortions of Goya; he also incorporated the rugged simplicity of Cézanne, and the emotionally expressive color of the German expressionists. The intensity of the work came from the intensity of this highly original, prolific artist, who died tragically young at twenty-eight.

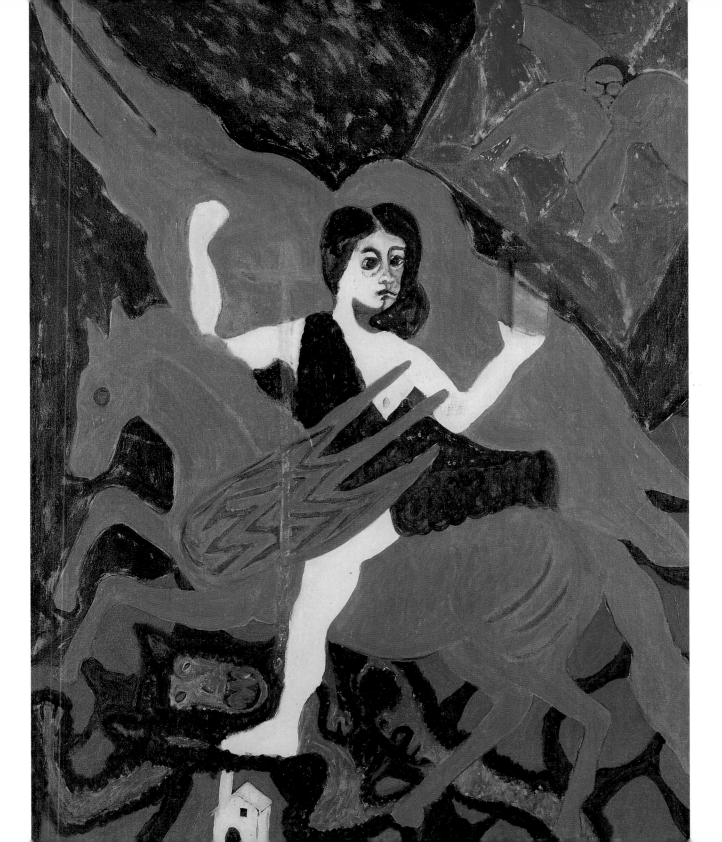

MAX WEBER

1881–1961

Summer

1909, oil
102.2 x 60.6 cm
Smithsonian
American Art
Museum,
Museum purchase
through the
Luisita L. and Franz H.
Denghausen Endowment

The voluptuous nudes, seductive poses, and the play of jagged foliage in *Summer* mark the maturity of Max Weber's fascination with primitive art, particularly African sculpture. The painting represents a primal urge to return to a simpler existence in harmony with nature.

Weber went to Paris in 1906 where he often visited Gertrude Stein's salon and was close friends with Henri Rousseau and Sarah and Michael Stein, who owned an unparalleled collection of Matisse's works. Weber's most important influence, however, may have been Cézanne, whose large bather paintings can be seen in *Summer*'s arrangement and composition. Painted just after his return to New York from Paris, *Summer* was exhibited in Alfred Stieglitz's pioneering 1910 exhibition, *Younger American Painters*.

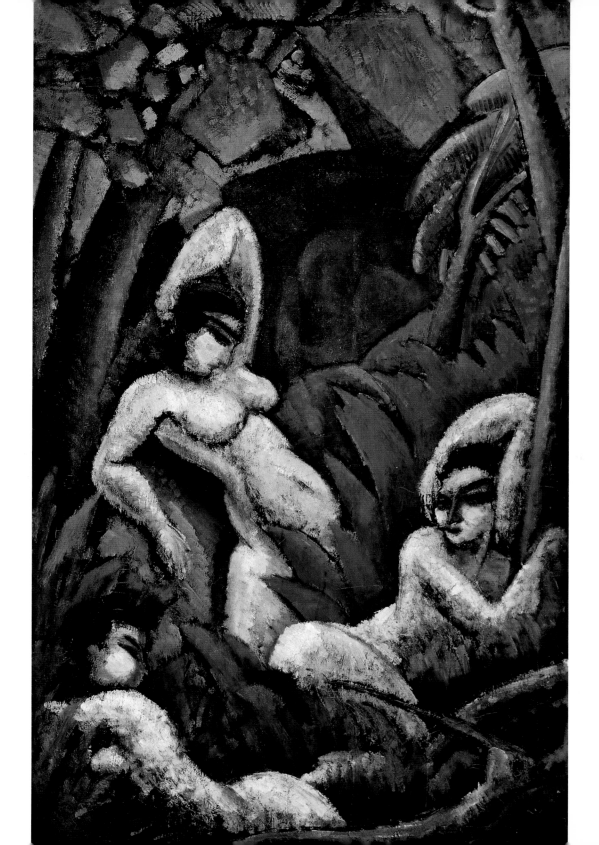

PAUL WONNER

born 1920

Girl in Swing

1957, oil
133.7 x 117.5 cm
Smithsonian
American Art
Museum, Gift of
Ruth J. Chase
in memory of
Dr. William Chase

We are attracted to the faceless woman because she is not the focus of the picture. Full of natural light and saturated color, this oblique view of a woman on a covered swing is one of Paul Wonner's ongoing painted meditations on the pleasures of life.

The close-up perspective, indicated by the tilting tabletop, is accelerated into deep space by the angle of the field until it meets the densely brushed green area that suggests trees. Wonner's expressive brushwork comes from his observation of nature. *Girl in Swing* has the sunlight, thick paint, loose brushwork, and bright colors characteristic of California Bay Area figurative painting, a pleasure-filled response to New York abstract expressionism.

Index of Titles

The Smithsonian American Art Museum is dedicated to telling the story of America through the visual arts. The museum, whose publications program includes the scholarly journal *American Art*, also has extensive research resources: the databases of the Inventories of American Painting and Sculpture, several image archives, and fellowships for scholars. The Renwick Gallery, the nation's premier museum of modern American decorative arts and craft, is part of the Smithsonian American Art Museum. For more information or a catalogue of publications, write: Office of Print and Electronic Publications, Smithsonian American Art Museum, Washington, D.C. 20560-0230.

The museum also maintains a World Wide Web site at **AmericanArt.si.edu.**